ROBERT WADE'S
WATERCOLOR
WORKSHOP
HANDBOOK

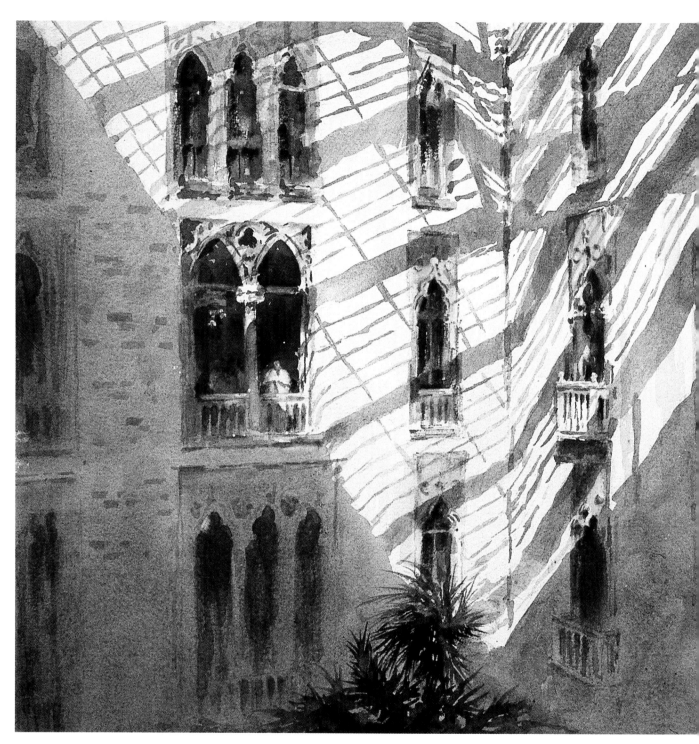

"The Atrium, Isabella Stewart Gardiner Museum, Boston," 20 x 30" (51 x 76cm)

ROBERT WADE'S
WATERCOLOR
WORKSHOP
HANDBOOK

May it please the Lord,
Light of all things,
To show me the way,
So that I may paint light worthily

— Found on a scrap of paper
in Leonardo Da Vinci's room

International Artist Publishing, Inc
2775 Old Highway 40
P.O. Box 1450
Verdi, Nevada 89439
Website: www.international-artist.com

Edited by Terri Dodd
Designed by Vincent Miller
Photography and illustrations by
Robert A. Wade
Typeset by Ilse Holloway and Cara Miller

ISBN 1-929834-15-2

Printed in Hong Kong
First printed in hardcover 2002
06 05 04 03 02 6 5 4 3 2 1

Distributed to the trade and art markets
in North America by:
North Light Books,
an imprint of F&W Publications, Inc
4700 East Galbraith Road
Cincinnati, OH 45236
(800) 289-0963

ACKNOWLEDGMENTS

To our 16 wonderful grandchildren who fill our lives with so much love.

To all of their parents who take them home at the end of the day.

To my students world-wide for their friendship and support.

To Vincent Miller, my long time friend, a visionary in art communication. He and
Terri Dodd, Editor/Executive Publisher, have made an enormous contribution to the
World of Art.

To my fellow artists who have encouraged my efforts for so long.

And, of course to Ann.
My wife, my counsel, my reason for being. She is the wash beneath my brushes!

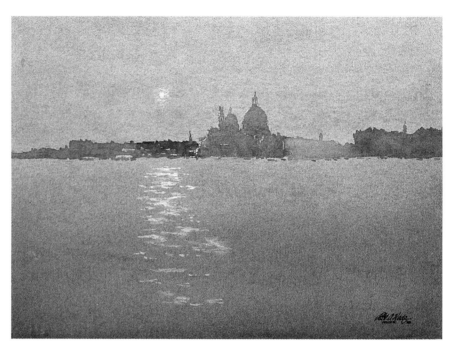

"Venice — A Moment of Magic", 11 x 14" (28 x 36cm)

"Denali Park, Alaska", 14 x 20" (36 x 51cm)
The wilderness is something special to behold and this fall setting conveys
the feeling of brooding isolation. The wildlife in the park is incredible:
bear, moose, caribou, mountain goat, Dahl sheep and more.

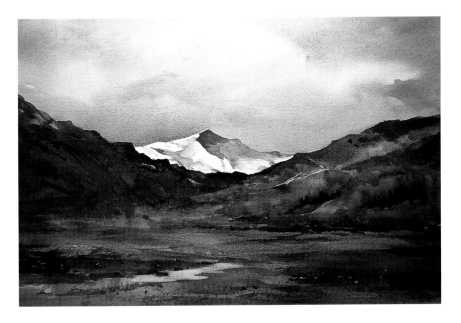

**"Mt McKinley, Alaska",
14 x 20" (36 x 51cm)**
The highest peak on the North American continent, Mt McKinley dominates the landscape around Anchorage as far as the eye can see. Many people who visit Alaska do not get to see the summit because it is mostly shrouded in cloud. It is a spectacular and awe-inspiring sight. I deliberately took the sky down in value to make the snowcap stand out.

PREFACE

Watercolor, the oldest painting medium known to humans since they mixed color to record the life around them on cave walls. The oldest, yet, for some unknown reason, the slowest to be recognized as a major medium in the Fine Arts. For so many years watercolor was regarded simply as a sketching medium, to be used in preliminary work for oil paintings and murals, or as an aid to military and naval commanders for recording the topography of battle areas.

Over the last quarter of a century, watercolor has spread its wings and has made its presence felt in all areas of art around the planet. There are millions of painters in watercolor, enthusiasts to a degree, producing brilliant, sensitive, dynamic or romantic effects to rival any other means at the artist's disposal. The brilliance and luminosity of transparent watercolor, when the substrate is allowed to shine through the washes and wet colors are encouraged to merge and mingle like living creatures, produces some of the most exciting, atmospheric moods imaginable.

Watercolor paintings have such charm, with their exquisite subtleties, or such power, through their dynamic color. Whichever way the artist chooses to work, watercolor has the ability to excite or arouse the emotions of the viewer more than any other painting process. Watercolor refuses to take a back seat, and at last the "upper echelon" of the art world is now sitting up and taking notice of our superb medium.

It is almost unbelievable that watercolor was ever pushed into the background after being taken to such heights by the great British Masters like Turner, Bonington, Girtin, Cotman, Cox and so many other wonderful painters of The Golden Age of Watercolor.

Today, once again we have marvelous exponents of the watercolor art working in most countries sharing their visions with fellow artists, sending a message of peace and understanding that surely cannot be ignored.

Not only do I get to travel the world, and to paint in the most wonderful places, but, through my writing, I also have the opportunity to communicate with all of you, my unseen and unheard audience. Sharing my thoughts, ideas, visions and dreams with you is so very special.

Being an artist can easily turn anybody into an introverted type of person. In order to avoid that situation, I find that I need to have contact with fellow artists, to communicate with my peers, so that I can maintain a balance between the isolation of the studio and the world outside.

Teaching workshops is one way of making this contact, and leading painting vacation groups on tours is another. Having had much experience in both areas over many years, I believe that I understand the needs of the average student in the search for information to paint better watercolors.

I offer you the benefit of my experience and hope sincerely that this book will be the means of enabling you to reach the next plateau in your artistic progress.

Here's to Watercolor!

Bob

Bob

CONTENTS

1 MATERIALS

SHOW ME WHAT I NEED

Papers: Surfaces, weights, size chart, characteristics, preparation
Brushes: Shapes and sizes
Palette types
Pigments: Basic selection and problem pigments
Other tools
Outfitting your studio

2 TONAL VALUES

SHOW ME HOW THAT WORKS

Shapes and tonal value
How squinting helps you see tonal values
Seeing and thinking in values
The cats-on-the-mat trick
Using your computer to check your work
A tonal value tale
Seeing values in a quiet corner in Venice
Tonal values project
Self-Assessment
Project — How changing values can change the mood — "Bonnie Doone"
Do-it-Yourself Exercise — Identifying the tonal value patterns in five different scenes

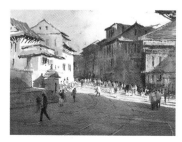

3 VISIONEERING & DRAWING

SHOW ME HOW THAT WORKS

VISIONEERING OUTDOORS AND IN THE STUDIO
Explanation of Visioneering
Do-it-Yourself Exercise—Visioneering by computer
Mini-demonstration — Visioneering in action
VISIONEERING ON SITE — ADVICE FOR THE OUTDOOR ARTIST
Artists make silent poetry
The painting frame of mind
Identifying good value patterns
The on-site process
Case study
Ways of working on site
Do-it-Yourself Exercise — Divided sheets
Sketching
Equipment for sketching
Contour drawing
Line and wash
Getting down to working on site
Courtesy and safety
Outdoor equipment
VISIONEERING IN THE STUDIO — ADVICE FOR THE INDOOR ARTIST
Studio procedures
The painting process
Major demonstration — Visioneering in action

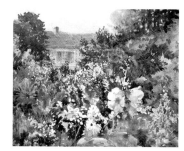

4 COLOR & GLAZING

SHOW ME HOW THAT WORKS

COLOR
Paint quality and consistency
Do-it-Yourself Exercise — Paper staining check
Do-it-Yourself Exercise — Getting to know the water/pigment ratios
Glowing washes start here
Making 200 colors from only six pigments
A series of Do-it-Yourself Exercises:
Mixing grays
Mixing greens
Mixing purples
Mixing browns
Mixing oranges
Mixing darks

Painting with a limited palette
5-minute color studies

GLAZING
The time-honored method of glazing
Do-it-Yourself Exercise — Traditional glazes
Wet-in-wet glazing
Do-it-Yourself Exercise — Using 8 glazes and still not making mud
More Do-it-Yourself Exercises
Do-it-Yourself Exercise — Reacting to color

Self-Assessment Critique
Examples — How different glazes can change the mood

5 FOCUS, EDGES & SHAPES

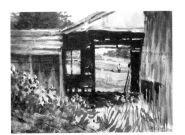

SHOW ME HOW THAT WORKS
FOCUS — AN EXPLANATION
Do-it-Yourself Exercise — Bob's Bullseye

EDGES — AN EXPLANATION
Directing the viewer's eye to wherever you want it to go using edges
Where do edges come from?
Do-it-Yourself Exercise — Making soft, hard and dry brush edges

SHAPES — AN EXPLANATION
Demonstration — focus, edges and shapes in action
Examples of soft and hard edges and how they were created

Self-Assessment Critique

6 SUBJECT SKILLBUILDING

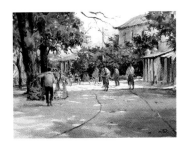

SHOW ME WHAT TO DO
PAINTING SHADOWS
What to do
Examples

PAINTING REFLECTED LIGHT
What to do
Examples

PAINTING AERIAL PERSPECTIVE
Understanding linear perspective
Understanding aerial perspective
Exercise — Checking your drawing
Examples

PAINTING SKIES
What to do
Do-it-Yourself Exercise — Sky studies
Examples

PAINTING WATER
What to do
Examples

PAINTING REFLECTIONS
What to do
Examples

PAINTING BOATS
What to do
Examples

PAINTING TREES AND FOLIAGE
What to do

PAINTING PEOPLE
What to do

PROPORTIONS
Self-Assessment Critique
"Bob's Blobs" explanation and Do-it-Yourself Exercise

7 THE BUSINESS OF ART

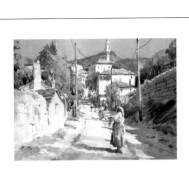

TELL ME HOW THAT WORKS
BEING IN BUSINESS — TELL ME WHAT I NEED TO KNOW
1. Your image
2. Systems
3. Photographs and how to take them
4. Bad art
5. Good art
6. Launching your art career
7. Getting into a gallery

CONCLUSION — WHERE DO YOU GO FROM HERE?
Beating the rejection blues
Inspiration

ABOUT THE AUTHOR

INTRODUCTION

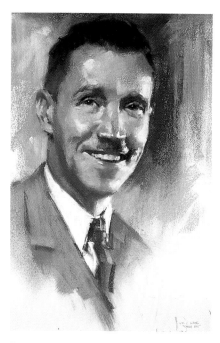

"Uncle Bill" by Harley Brown, pastel, 14 x 18" (36 x 46cm)
This superb painting of my late uncle sits on my studio wall and overlooks all that I do. I look at it every day and hope that he approves.

"I do not report the fact: the camera can do that! I have an intense dislike of any so called painting rules that preclude my desire to rearrange my subject. My painting will not be an accurate facsimile of what appears before me, it will be a sincere representation of how I FEEL about what I see. I want complete freedom to dramatize, romanticize or fantasize, or to do whatever will allow me to make my personal statement."
— Robert Wade

"Dad, I want to be an artist!" What would YOUR reaction be if this statement were to be put to you by one of your teenage children? I guess that it may be a bit like the old Music Hall song, "Don't put your daughter on the stage, Mrs. Worthington".

The arts generally are not held in high regard as a means of earning a good, steady income. Most parents shudder at the thought of an offspring struggling to make a reputation and a comfortable living in such a mercurial environment.

Because my Dad was a Graphic Artist, or a poster artist as they were called in the 1920s, I don't think it would have been much of a surprise to him when his eldest son professed a desire to follow in his footsteps. I never wanted to be anything other than "an artist, like my Dad". I was born just five minutes away from the famous Heidelberg School artists' camp, and on my Birth Certificate the word "Artist" appears under "Father's Occupation". It almost seems that art was to be my destiny!

I can't recall a time when I did not have a pencil, crayon or brush in my hand and I cannot remember ever being discouraged by my parents to turn from my chosen path. When my father died in 1949, at the tragically early age of 38, I was aged 18, so I left school and took up the running of the family business, a display and screen-printing company. I ran that company for the next 40 years and enjoyed every day of my life in graphic art and design. However, I never lost sight of my goal, a career in the fine arts . . . in particular WATERCOLOR, which had always been my great passion.

My Uncle Bill was also a poster artist and he encouraged me to paint whenever I had the chance. He also critiqued my work whenever I needed help and he was a very severe critic. I felt that if he ever gave me some praise, then I had really earned it. I don't think that there is a better way to learn, really, than being left to develop in an individual way instead of being forced into the methods of a teacher. Uncle Bill was a great bloke and he also introduced me to golf, my other love for the last 53 years!

I continued to paint in my spare time but, with a young family and a growing business, I had very limited time for painting, and I would not have produced more than about a half dozen per year. In 1972 my mother gave me a Christmas gift that suddenly fired me with enthusiasm to get more involved with the fine arts. The gift was a wonderful book, *Watercolor* by John Pike. I just loved his strong dynamic paintings and enjoyed his friendly advice on the way to work with the medium. It really fired me up and I still thumb through that volume with much joy.

My hope is that there will be someone who might react to MY book in the same way and use it as a springboard to success in the wonderful world of watercolor.

From 1976 onwards, watercolor was an obsession and, until I sold the Company in 1989, I painted every night and weekend to try and achieve my goals. The old saying, "The harder I worked the luckier I got", certainly came true. There is no substitute for PRACTICE, PRACTICE, PRACTICE! Sheer application will

always beat sheer talent!

Over the last 15 years or so I have traveled the world teaching and painting. My workshops have taken place in 39 different countries so I have had the opportunity to watch the reactions and abilities of many people, who are basically the same wherever I go. Their language and cultural characteristics may change, but what is inside their hearts does not vary much, particularly with those who paint in watercolor. Watercolorists are humble people, the medium does not allow us to be otherwise, and we are united by a love for our medium and an appreciation of the world around us.

I have been privileged to have the company of so many wonderful people who have enriched my life and become members of my extended family. As the time has now come for me to quit from my travels and concentrate on my own painting, I know that it is their love and friendship that I will miss most of all. I must honor the huge number of requests from these friends and set down in print my teaching messages and methods, which I believe are all fundamental to the painting of better watercolors in the traditional manner.

This book is a reference manual. It is not an opportunity to showcase my own paintings, rather it is intended as an invaluable source of information for all watercolor painters, from amateurs to professionals, who seek to find the answers to the problems encountered in our never-ending search for knowledge.

This volume should not spend its life sitting on a bookshelf. It should become much worn, much flagged and,

I hope, much loved and respected. It should sit on studio tables and workbenches like an old friend, to provide a ready reference for helping to solve queries that constantly occur in the course of our work.

Let me hasten to add, however, that I can only provide you with much valuable technical knowledge — YOU must provide the major ingredient, which is essential to the making of good paintings. That most important ingredient of all is EMOTION. Without it your work will be clinical and sterile, clever in its execution perhaps, but devoid of feeling, your contrived and emotionless efforts arousing no reaction from the viewer.

There is no positive direction that you can take from these pages without thinking about it and applying it to your own particular work. Life would be too easy if all the answers could be written down and simply found in a book.

So, filter my suggestions with a deal of your own knowledge, personality and emotion and, between the two of us, let's hope that we can arrive at a satisfactory conclusion. HAVE FUN!

Your collectors deserve top quality pigments and papers. If you can possibly afford it, I always recommend that you use the best materials.

MATERIALS
SHOW ME WHAT I NEED

The old saying, "A tradesman is only as good as his tools", still holds true today. But it's no good having the best tools and materials if you don't know how to use them, and you don't understand their qualities and characteristics in order to derive the most benefit from the products.

So in this chapter I want to discuss the basics with you, so that you can continue with your investigations and make personal decisions and choices.

"The brush is an extension of the hand, the hand is an extension of the arm and the arm is an extension of the heart. What is felt in the in the heart flows down the arm, the hand and the brush, and so flows out onto the paper."
— Oriental teaching

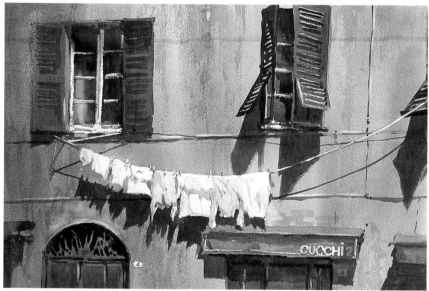

EFFECT ON COLD-PRESSED SURFACE
"Drop A Line", 14 x 20" (36 x 51cm)
Smooth, Cold-Pressed paper assisted me in getting the variations of color in that very attractive wall. A Rough paper would have been more help in obtaining the textures, but we can't have everything!

PAPERS
- **SURFACES**
- **WEIGHTS**
- **CHARACTERISTICS**
- **PREPARATION**

The choice of paper can measurably affect the result of your painting, so give due consideration to the type and surface quality before selecting your sheet for the job. Each manufacturer puts a different finish on the paper so it's essential that you know the characteristics of each available sheet. I'm not going to discuss the various papers except to say that I am currently using Saunders Waterford Rough, 140lb (300gsm) and Whatman Rough 200lb (420gsm).

Rough:
I recommend the Rough surface, sometimes called Not surface, to my students because I believe that it generally gives the most assistance to the artist. Many different effects can be obtained from the grainy surface, ranging from smooth washes to rough-edged dry brushstrokes. Whenever your subject has heaps of textures in it, then selecting Rough will certainly help you to obtain this result.

Cold-Pressed:
Cold-Pressed, a much smoother surface, will be sympathetic to very smooth gradated washes and to subjects where there is a fair amount of detail. Pen and wash works well on Cold-Pressed finish.

Hot-Pressed:
Hot-Pressed is a specialized paper, not really recommended for student work. The amount of sizing on the surface needs to be handled by an artist of considerable experience, otherwise the danger of lifting some underpainting is very real.

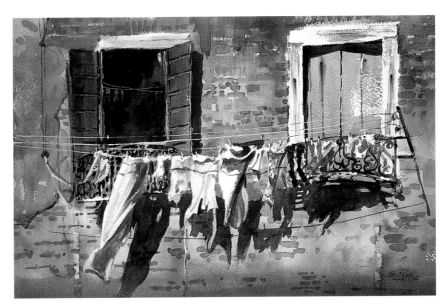

EFFECT ON ROUGH SURFACE
"Hangin' Out, Venice", 14 x 20" (36 x 51cm)
Waterford Rough gave me the best of both worlds for this typical Italian scene. Lots of textures and dry brush strokes. Note how the rough edges suggest movement. This painting is a bit unusual for Venice — no water, no gondolas!

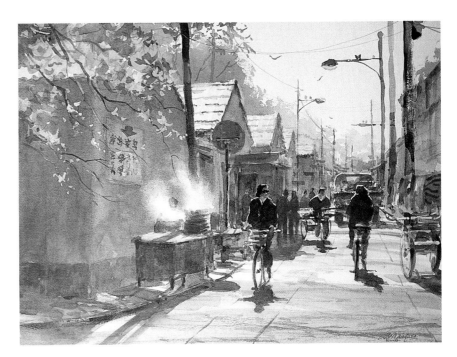

EFFECT ON COLD-PRESSED SURFACE
"Beijing Morning, China", 18 x 25" (46 x 64cm)
I used Cold-Pressed paper here because I was so keen to get the feeling of the steam coming from the dim sim boilers. I had to watch that area while it was drying, and keep dabbing with a tissue to ensure that it did not dry with hard edges.

PAPER SIZES

Here are the various sizes of paper sheets:

Elephant	40 x 25 inches	(102 x 64cm)
Full Sheet	30 x 22 inches	(76 x 56cm)
Half Sheet	22 x 15 inches	(56 x 38cm)
Quarter Sheet	15 x 11 inches	(38 x 28cm)

The weight of the paper refers to the number of grams per square metre (indicated gsm) or the number of pounds in a ream.

Paper storage rack in my studio containing stocks of top quality brands of artists' watercolor papers

PREPARING PAPER FOR PAINTING

My method is simply to tape the sheet all around to my drawing board with one-inch masking tape, making quite certain that it is evenly applied, half on the paper, half on the board. When the painting is completed, I remove the tape very carefully and the result is a neat, clean border. It's always advisable to remove the tape with the aid of a hairdryer — the hot air will soften the tape adhesive and prevent unwanted tearing of the surface. Some papers won't be a worry in that respect, but if you are using an extremely soft surface like Bockingford, for instance, watch out, because you can inadvertently rip out a large chunk of surface paper with your tape and spoil your finished painting beyond repair!

Paper taped down to my board

Whenever your subject has heaps of textures in it, then selecting Rough surface paper will certainly help you to obtain this result.

Weights:
Most papers come in two weights, light 140lb and heavier 300lb (300gsm and 620gsm). The 300lb paper has a great advantage in that there is not much buckling while you're painting, but it is very expensive and very heavy to carry in a packed folio. I also think that the surface of the heavy papers is never as grainy and rough as the lighter weight. You will have to make your own decisions on just what suits you.

Stretching:
I never stretch my paper, simply because I don't have time and because I don't really worry much about the buckle in wet 140lb paper. If I were to use a 90lb paper (a weight that some of the tinted sheets come in) then stretching would be essential.

BRUSHES

When I began painting watercolors way back in the late 1940s, the standard brush was made of pure sable. I wish that I had purchased a million of them because they were very cheap then, but they became ever more expensive and harder to obtain as farming the sables proved more difficult.

In the last 20 years many synthetic, nylon filament brushes have come on the market. They are very hard wearing, long lasting, resilient, flexible and economical. They point well and retain their point far longer than sable. I also think most of them have more spring than sable and they take enormous punishment but still come up smiling, reverting back to their original shape with just a dip into water and a couple of vigorous flicks.

Personally, I dislike squirrel mops, absolutely hate hakes and consider Chinese calligraphy brushes quite hopeless for watercolor painting. Any more questions?

Brush shapes:
Brushes for watercolor painting come in mainly two shapes, rounds and flats. The choice here is a personal one and only you can decide which suits you better. I use both flats and rounds and have a wide range of sizes, from my great signature brand Robert Wade 1½" flat, through 1" and ¾" then to the rounds — No's 36, 24, 20, 16, 12, 8, 6 and 3 — and a couple of riggers.

My advice to you is to use the largest brushes that you can in your paintings until it's no longer possible to get the strokes you need. Then change to a slightly smaller brush size, and so on. Brushes that are too small for the job lead to niggling and stippling strokes, thus bringing about the ruination of a painting.

My "Robert Wade" signature brushes in rounds and flats.

The 1½" flat is my best friend, I use it on every painting for as long as I possibly can.

Personally, I dislike squirrel mops, absolutely hate hakes and consider Chinese calligraphy brushes quite hopeless for watercolor painting. Any more questions?

PALETTE

In any workshop, the most amazingly varied array of palettes turns up. Some big, but mostly small, round, broken, dirty old plates, TV trays — almost anything will do. Most of them will have every well filled with a different color, and most have minute deposits of paint in them. Students generally are very miserly about squeezing out color. They put out about one-enth of a gnat's nut then, they expect to mix enough wash from that bit to paint a full sheet!

Be certain that the palette you buy has big wells, so that it is possible to put at least half a tube into each well. My own palette has wells of 1¾" square and 1" deep. I squeeze out almost a whole 14mL tube into the 20 wells that I use. Even with my 1½" flat I can get in there to pick up heaps of color when I need it in a hurry, instead of scratching away at some tiny little spot of pigment about the size of a rabbit's dropping. The color will last, don't think that you are being extravagant, it will only need a squirt from your water spray before your next painting session and the moist color will be like new.

I have also added a solid base of galvanised iron to my palette. I had this made with a "curl-over" on three sides that allows the palette to slip in snugly. This gives some weight to the palette, preventing it from blowing away off my easel when on-site, and also this protects the fairly thin base of the palette at all times.

PIGMENTS

Because price is always a consideration for students many of them use student quality paint. I believe that this is false economy because you have to use more of this pigment to equal the intensity of artist's quality paint.

If you can possibly afford it, I always recommend that you use the best paint. Your collectors deserve top quality pigments and papers.

My own palette consists of the colors shown here.

COLOR SWATCH

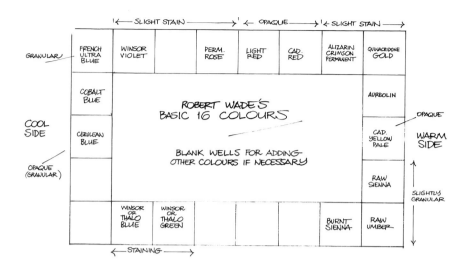

Remember, these colors suit me but they may not suit you.

Cerulean Blue	Cadmium Red	Raw Sienna
Cobalt Blue	Alizarin Crimson	Raw Umber
French Ultramarine Blue	Permanent	Burnt Sienna
Winsor Violet	Quinacridone Gold	Cadmium Lemon
Permanent Rose	Aureolin	Phthalo Green
Light Red	Cadmium Yellow	Phthalo Blue

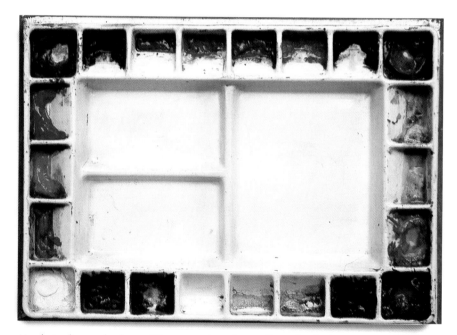

My choice has evolved over 50 years and maybe it still isn't finished even yet, because I intend to try out any new colors that may come along. Quinacridone Gold, for instance, is the latest addition to my palette, and I think it's the best thing for years.

I keep some wells blank just in case anyone invents some more new colors that suit me.

PALETTE ARRANGEMENT

When arranging colors on my palette I put cool colors on the left and warm colors on the right. I never change the layout and can find the correct colors in the dark. If I turned the palette around the other way I'd be lost. Imagine how typists would feel if the letters "q w e r t y" were suddenly switched from their familiar line of the keyboard down to the bottom. They'd all have a fit!

By arranging my palette consistently, I know instinctively where to reach to warm it, cool it, lighten it or darken it. I don't think of the names of the pigments, I don't say to myself, "I'll have a touch of Cobalt Blue and bit of Raw Umber", I just go to these wells thinking warmer, cooler, lighter, darker.

You must be as familiar with the colors and their qualities and positions as the pianist is with the notes on the keyboard. Play your palette in the same way, darting from note to note, in order to paint your own tune.

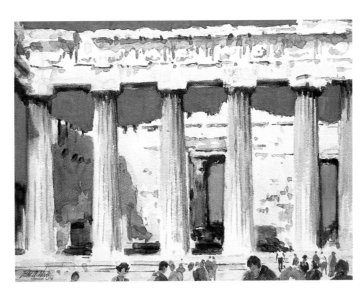

"The Acropolis, Athens", 11 x 14" (28 x 36cm)
The sky was so intense that I felt I could cut it with a knife, so I decided to use gouache, but only for the blue of the sky.

All watercolor washes will dry at least half a value lighter than you think. So remember the old adage, "If it looks right when it's wet, it's wrong".

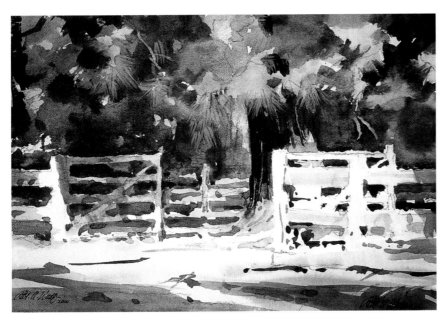

"Flinders Gate", 11 x 14" (28 x 36cm)

SPECIAL NOTE: PROBLEM PIGMENTS

My present palette of colors does not include Burnt Umber, Yellow Ochre or Payne's Gray (and when you mention that color, say it in a hushed whisper!). The reason I don't use them is that each of these colors produces mud very easily, so it's a smart move to delete them from your selection.

There are substitutes. For instance I would mainly use Burnt Umber as a mixing color, and I can approximate that by mixing French Ultramarine and Burnt Sienna.

As well, why flirt with the possibility of making mud by using opaque Yellow Ochre when you can use Raw Sienna, which is very similar but is totally transparent!

The other problem color, Paynes Gray, dries several values lighter than it appears when you put it down on the paper. This invites you to add more glazes to build up to the required value — so why not drop Paynes Gray and eliminate another problem?

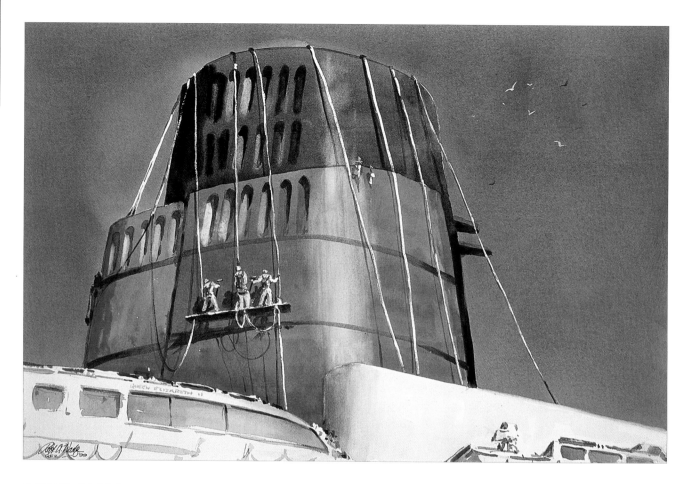

OTHER TOOLS

Pencils:

I always make a preliminary drawing with a 4B pencil because its soft tip gives a nice, indefinite line, does not damage the surface of the paper, erases easily when the job is done and gives a painterly feel to the drawing before I even begin to paint.

Pens:

I've never been able to resist new products, especially pens. I have no idea how many I have, varying from fountain pens, calligraphy pens, brush pens, nylon tipped pens, technical pens, lettering pens, felt markers and on and on. My only advice to you is to make sure that you understand what a pen will do. Ask the following questions:

- Does the nib glide over the watercolor paper? Or does it catch and dig into the texture?
- Is the pen waterproof and light-fast?

These questions must be answered before you use the pen on your work.

I'll cover this in more detail in the section on drawing.

Masking Fluid:

There is potential disaster awaiting the user of rubber solution block-out. When the fluid is removed from your painting the result often looks like a bundle of white worms stuck onto the background. It takes very thoughtful use of a little scrubber brush to soften those razor-sharp edges and make them fit into the painting. The mechanical appearance of those saved whites can overpower your painting and destroy any feeling of spontaneity which, after all, is one of the intrinsic charms of our beloved watercolor medium.

In all of my years of painting I can't recall having used masking fluid more than a dozen times. I prefer to take up the challenge of guiding my brushes around the reserved lights rather than take what I consider to be the easy way out.

**"QE2's New Coat",
14 x 21" (36 x 53cm)**
This is one of the few times that I used masking fluid. I used it on the painters and the ropes. I exaggerated the thickness of the ropes to make a better pattern of the light shapes. When the rubber masking solution was removed it left me a job to do in softening edges to make them fit in naturally.

OUTFITTING YOUR STUDIO

Your studio. Your personal kingdom! Your workshop! Your factory! Here's where you are in complete control and if you want to leave paintings half done or scatter them on the floor from one end to the other, you surely can!

It's essential that you have your own space and you are able to close the door and walk out whenever and however you want. If you are a kitchen table painter, this isn't possible. You do need a separate room, maybe you might have to wait for one of your children to marry and vacate — "I am not losing a daughter, I am gaining a studio!" When at last you have that private area, then it's time to get down to serious work because there's no longer any excuse for not painting.

Be sure you are comfortable and that everything you need is there to make it a true working area. You will not need state-of-the-art taborets, filing cabinets and studio furniture unless you are a top pro and can afford that luxury. Some old chairs and tables from local garage sales, maybe a cabinet with drawers, and that's it!

KEEP IT WARM AND COOL

My own studio is a place where I love to be. I feel totally at home and enjoy several luxuries there. One is reverse cycle air-conditioning that keeps the temperature constant and comfortable in any season. Melbourne never becomes too cold, about 57°F is our average winter day, although summer can be very hot with temperatures of 95°F to 104°F, making it hard to paint without that air-conditioner unit in the studio.

My other luxury is my sound system. CD's are playing non-stop. My taste varies from classical to jazz and seems to change with the mood of the subject that I am currently painting.

STOCK IT PROPERLY

In the studio, I keep stocks of most papers, and at least six large, spare tubes of every one of my watercolors, then there are sketchbooks, boxes of pencils, spare rolls of film, cameras, tape recorders, videos, my library of books and my library of 70,000 color slides. My studio also contains finished paintings, both framed and unframed, palettes for the use of my grandchildren (they must not use mine!), easels, travel bags and folios, a putter and a couple of spare golf clubs for practice swings to relieve the concentration, and art magazines from all around the globe. Then there's my PC, scanner, printer, fax, photocopier and office files, and that's almost it.

I've also kept a daily diary since I was 8 years old, so I have a big pile of seldom opened writings to take up a bit more space. As you can see, if all of these pieces were not carefully stored then I'd be in a real mess. Luckily I am a very organised person so each thing has its place and is always returned there after use.

CONSIDER THE LIGHTING

One of the critical items in my studio is lighting. I paint under artificial light so that it is always constant, and whether I'm working at 5.00 am or 11.00 pm, there is no change. I use two different fluorescent tubes, one 40" Verilux Full Spectrum and two 15" Durolite True-lite, 54/27. These tubes are all made in the USA and closely approximate daylight. However, if you can only obtain regular tubes then mix them up with one warm and one cool and that will give you a reasonable result.

My studio workbench

Studio workspace

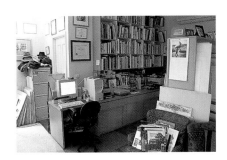

Computer workstation and library

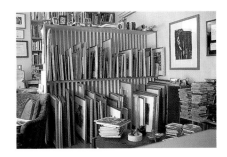

Storage for finished framed work

You can have the most technically perfect drawing, and use the purest of colors, but you will not make a good painting if the tonal values are all wrong.

TONAL VALUES
SHOW ME HOW THAT WORKS

"In art, we have rare times when our vision extends beyond the normal and everyday. We seem to be on another plane, in another world of creativity and sensitivity that leads us on to seek understanding of the purpose for being what we are."
— Robert Wade

I believe that recognizing and translating TONAL VALUES is the most important key to producing outstanding works of art. This is not a new idea — it has been understood by all the great painters who have ever lived. If you make the effort to look at works by Turner, Homer, Sargent, Flint, or any of today's Masters, you will soon see how each one used contrasts of value to make the shapes work.

What do I mean by making shapes work?

SHAPES AND TONAL VALUES

I am sure that at some time in your painting career you have been unhappy with a shape that didn't do what you had hoped. That white barn, that old white church or that lighthouse just didn't seem to stand out enough — and it was the point of the painting. The thought comes to mind, "I think I need to put a black outline around that shape in order to get it to work". If you have encountered this scenario, then you can be certain of one thing . . . YOU HAVE FAILED IN YOUR PLACEMENT OF THE TONAL VALUES.

Consider this: there are no outlines in Nature. We are able see things (shapes) because of the surrounding contrasts, and the contrasts are stronger or weaker depending on the quality of light present at the time.

I would like you to examine some of your own paintings right now. Be critical of their tonal values and determine whether you have actually succeeded in making the important shapes work, or whether your interpretations of the values have let you down.

But, don't despair, in all my workshop classes over the years, I have seen so many works by students that needed only slight adjustment of tonal values to turn them into successes.

As a result of my observations, I have no hesitation in declaring that the ability to assess and use correct tonal values is the most important attribute any painter can have. Despite poor drawing or dirty color, a painting may just work if the tonal values are used to advantage. On the other hand, the most technically perfect drawing and the purest of colors will not make a good painting if the tonal values are wrong. I am neither condoning bad drawing, nor approving the application of mud, merely pointing out the relative importance of the main ingredients of a painting. This applies to every medium, not just to watercolor.

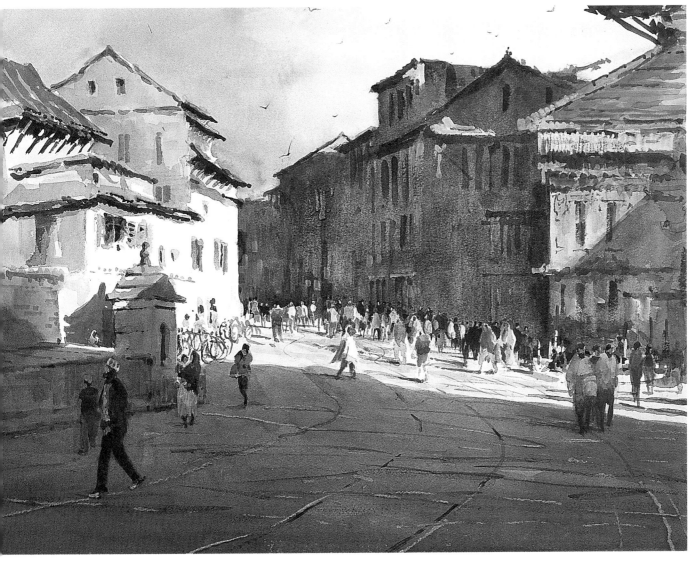

"Afternoon Light, Bhaktapur, Nepal", 14 x 18" (36 x 46cm)
Here, in order to express the brilliant light, I utilized the full tonal value scale from dark to light. Placing the lightest light against the darkest dark provides an irresistible focal point. Note the counterchange of the figure in the white jacket — the top half is light against dark, the bottom half is dark against light.

EXAMPLE

SEEING AND THINKING IN TERMS OF TONAL VALUES

In our home we have a couple of cordless telephones that we tend to leave somewhere and then can't find when these phones ring. (These are older handsets without the "locating" button, I hasten to add.)

One phone is black, the other is pale gray and the difficulty is in finding one or the other! Frequently we would miss a call because we couldn't see the phones before the caller hung up! More often than not, it was necessary to call the number of whichever phone was lost using my static studio line and then play our little game of "hunt the cordless phone". This was pretty stupid, so something had to be done about the situation.

The solution was to use TONAL VALUE to make the phones visible.

Now, when we move round the house taking our cordless phones with us, we are always careful to place the black phone on a light value background, and the pale grey one against a dark background. Problem solved!

LEARNING POINT

The phone shapes were evident simply because of CONTRAST, exactly as in any painting. The shapes in your paintings are visible only because of the juxtaposition of the contrasting TONAL VALUES. Do you get the picture?

SEEING AND THINKING IN TERMS OF TONAL VALUE

Acquire the habit of seeing AND THINKING in TONAL VALUES.

As you look around you at work, play and leisure, ask yourself, " WHY? Why can I see that shape?" Look closely at the edges of shapes and compare their relative tonal values. Is the value lighter? Is it darker? Is there a major difference — or is there a very subtle difference? Think in terms of light tones, middle tones and dark tones. Look at other paintings, at the works of the Masters and of successful painters of today. Study the pattern of light, medium and dark tones in their paintings. It is imperative that you recognize the importance of this aspect of your work.

Once you have mastered the ability to identify and use tonal values, then you will be able to portray a subject in many different moods and lights. Your boundaries will grow ever wider and one subject will turn into 20 as you invent and "Visioneer" an endless array of varying effects. You will truly be in the driver's seat! (I'll tell you about Visoneering in Section 3.)

If you only learn one thing from this entire book, make understanding tonal value the major piece of knowledge that you can acquire.

If you have not realized this truth before, once you have grasped it your paintings will become better and better.

The reason this section on TONAL VALUES is right at the beginning of the book, is that I want you to understand it as clearly as you can, because the rest of the information will not mean a thing unless you have come to terms with the "cats-on-the-mat" example below. The images you store in your memory as a result of those word pictures will come back to you constantly and help you realize how simple the whole process is if you just stop and think about your subject in terms of TONAL VALUES.

EXAMPLE

THE CATS-ON-THE-MAT TRICK

Notice the visibility, or otherwise, of these cats. Now you see 'em, now you don't. They become visible, or more difficult to see, according to the values of the surrounding shapes.

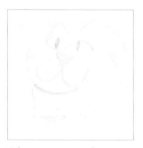

White cat sits on white mat . . . moves across gray slate floor . . .

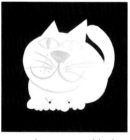

. . . and jumps onto black couch. Black cat on black couch . . .

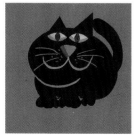

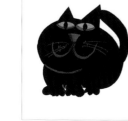

. . . jumps onto gray slate floor . . . moves onto white mat.

Imagine walking into a room and stepping onto a big white lambskin rug. Whoops! You almost tread on a white Chinchilla cat which is having a quiet snooze and is almost invisible because it is a light shape surrounded by a light shape. There is no contrast.

The cat, disturbed from its slumber, walks across the mid-value gray slate tiled floor, instantly becoming visible because it is now a light shape surrounded by a mid-value shape. It continues walking until it jumps up onto a black leather couch on the other side of the room. Here we have the maximum contrast — lightest light surrounded by darkest dark. But it doesn't end here!

Previously unnoticed, a black cat is dozing on that black couch, invisible to you because it is a dark shape surrounded by a dark shape. Jumping down quickly, the black cat walks across the mid-value tiled floor and becomes a small dark shape surrounded by a mid-value shape. Once again there is contrast. The black cat takes up the position on the white rug that was previously occupied by the white cat. The maximum contrast is once again achieved — darkest dark surrounded by lightest light!

Now, instead of being invisible to you when you entered the imaginary room, both cats are clearly defined. What happened? Did the cats change their colors or values? No! They moved and changed the values of their surrounding shapes, and in doing so created CONTRAST!

LEARNING POINT

If you can think of these cats and apply the same theory to your paintings then you will have mastered the idea of TONAL VALUE.

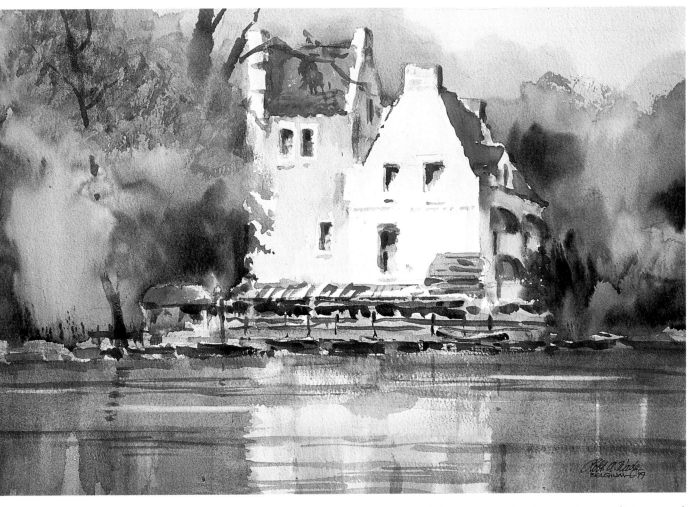

"Zuitewater, Belgium", 14 x 20" (36 x 51cm)

SQUINTING TO SEE SIMPLE SHAPES

When I was a small boy I was always hanging around my Dad's art studio in the hope that I might be allowed to do a little of the background painting of some display that he was producing for a movie promotion. I vividly remember waving a loaded 3" brush, nearly as big as myself, over the sea area of a display for the Charles Laughton version of "Mutiny on the Bounty". Another especially memorable highlight was painting the side of a pirate ship for "Sea Wolf" starring Errol Flynn! What happy days

they were, and I spent many such times just watching Dad at work.

I was always intrigued to see him squinting his eyes, constantly walking back from his painting to view it from a distance. At the time, I never really understood what he was doing, but I certainly do now! He was squinting in order to see the SIMPLE SHAPES and so eliminate detail, thus making the recognition of TONAL VALUES relatively easy. Getting away back from the work enabled him to see it as a whole and not become locked into isolated areas of detail.

LEARNING POINT

Here is an example of the white cat on the mid value background!

This was a demonstration I used in one of my videos and it was painted with the express purpose of showing how big shapes and tonal value patterns always produce reasonable paintings.

HOW SQUINTING HELPS YOU IDENTIFY TONAL VALUES

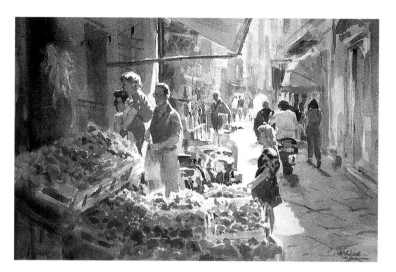

**"Morning Market, Sorrento",
15 x 20" (38 x 51cm)**
This on site class demonstration is a
fairly factual representation of the
scene. However, it was only after
I did much squinting that the shapes.
In the following computer-generated
examples i show you how squinting
worked on that occasion.

**The first squint:
eyes narrowed down**
This computer simulation shows
what I saw when I squinted.
Much of the detail was
eliminated so I could isolate
the passage of the light shapes.

**The second squint:
eyes almost shut**
This was the view with my eyes
almost shut. There was just
enough vision through my
eyelashes to allow the shapes
of the light to become apparent.
All detail was eliminated and
the scene was almost reduced
to monotone shapes. That
means I could allocate shapes
into their various values.

OK. Now do you get the
idea? Are you beginning to
realize just how critical values
are to the success of your work?
So SQUINT, SQUINT, SQUINT!

*A very simple way of seeing tonal values is to change
your subject into black, white and half-tones of gray.*

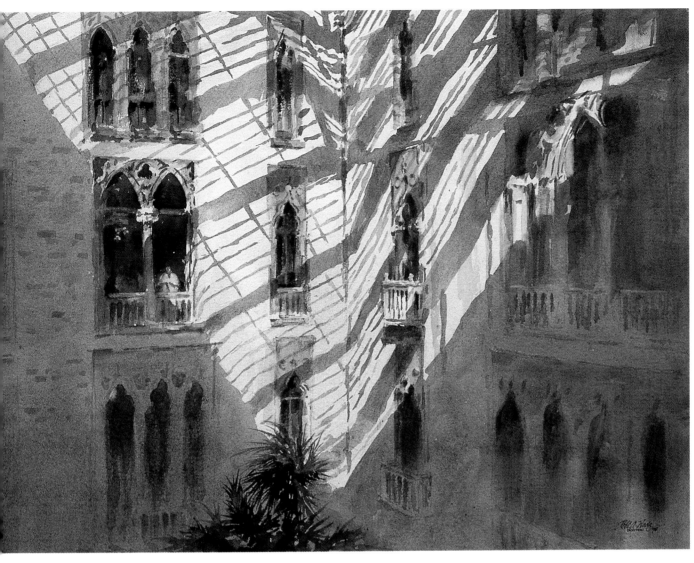

"Atrium", 20 x 30" (51 x 76cm)

Think about the "Cats" example and study the play of light, mid and dark values in this scene. Squint and you will be able to identify the different values in this painting, which is composed of three main triangular shapes. Notice where the lightest lights play against the darkest darks. See how I made some areas less important by using soft edges and mainly middle values, and how I achieved drama by using a dynamic juxtaposition of criss-crossed light and mid-values.

Light
Here, we see dark windows surrounded by a square of mid-value which is on a predominantly light area.

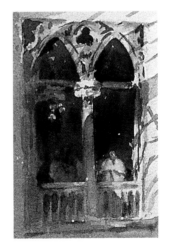

Medium
In this section, dark windows have mid-values on the left and light values on the right.

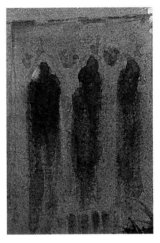

Dark
To give less importance to the lower area of the building the soft, dark windows are surrounded by a mid-value.

EXAMPLE

2

TONAL VALUES

WHAT YOU SEE WHEN YOU SQUINT

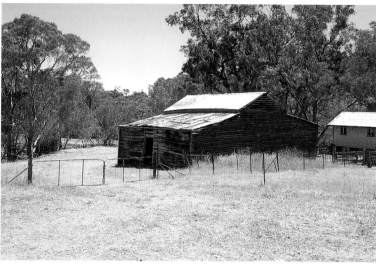

The first squint — eyes narrowed down
When you start SQUINTING the big shapes become apparent and the tonal values just jump out at you. Isn't it so much easier to see your lights and darks this way?

Here's a photograph of a typical scene
Here the tonal values are very well defined, even when looking at the subject in the normal way.

The second squint — with eyes almost shut
This is what you see with your eyes almost closed. An abstract monotone pattern has emerged and the whole scene is reduced to its simplest form. The more you can simplify the subject, the easier it becomes to paint. The simpler your rendering becomes, the easier it is for the viewers to interpret your reaction and feelings. This example has been reduced to about two values, but look how well they work to tell the story.

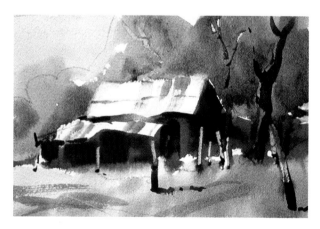

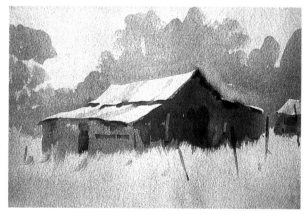

The color value sketch
The next step is to make a small value sketch using the information your squinted eyes give you. It doesn't have to be a big production — I completed this sketch in about five minutes. It is only possible to do this when you have gone through the squinting process and have observed the VALUE PATTERN! DO NOT PRODUCE A FINISHED PAINTING AT THIS STAGE! This is only your blueprint for success, it must be simple.

The finished study
From all the observations, plus a tonal value sketch, we now have a pretty good idea of where we are going. We know where the lights and darks are and we have a feeling for the old barn. I had previously given this 10 x 6" piece of paper an overall wash to tint the background. Then, with only a #12 brush, and without pencil drawing of any kind, I completed this study in just five minutes.

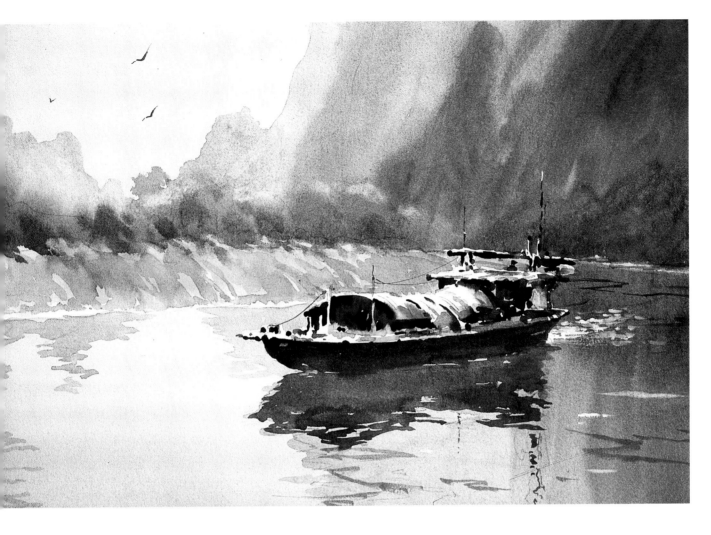

HOW SQUINTING HELPS YOU IDENTIFY TONAL VALUES

Most good artists squint at their work to help them resolve the problem of deciding the relative values of tone — light, middle and dark.

Here's how I do it. I always stand to paint, whether in the studio or on site, and that makes it easier for me to constantly walk away from my easel to squint at my work, just as my Dad did.

Now you try. Scrunch up your eyes until you are just looking through a couple of slits. You will immediately find that a lot of detail has been lost and many shapes are joining and simplifying because of their closeness in tonal value.

The tighter you scrunch your eyes, the more the colors and definition will be lost, and the more the image shows up as a black and white collection of abstract shapes. You have just identified the tones!

Some of the artists of yesteryear used what was called the Claude Mirror to help them identify correct values. This was a piece of glass coated with a matte black paint on one side. When it was held up to reflect the image of a proposed subject (in reverse of course) the values became easier to determine. Personally, I think scrunched-up eyes do it better, but maybe you might have a trick or two up your sleeve that will work for you. No matter which method you use, as long as you are able to recognize the tonal values, then who cares how you do it?

"Sampan on the Li River, China", 18 x 24" (46 x 61cm)
This was one of the most memorable days of our time in China. Life on the river has hardly changed over the centuries so it was like being in a time warp.

LEARNING POINT
The sampan's shape is a play of dark against light. The shape merges at the bow with the mid value of the water. In order to create contrast with the light shape of the canopy I decided to make the river bank a good value darker than it actually was. Remember, you don't have to paint exactly what you see.

25

LET'S SQUINT AT THIS PHOTO OF A QUIET CORNER IN VENICE

All the confusing elements in the scene must be eliminated. It will be necessary to see in terms of out-of-focus shapes. How do we do that? By squinting, of course.

Squint
Scrunching up your eyes will help you see the big light and dark shapes.

Squint harder
Here's the scene reduced to the basic tonal values.

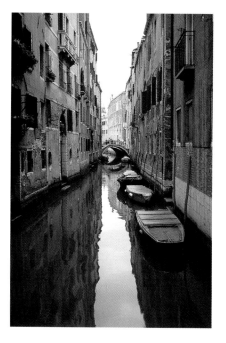
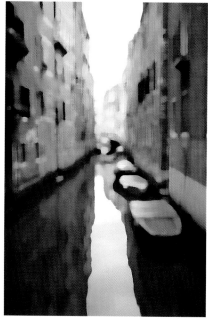
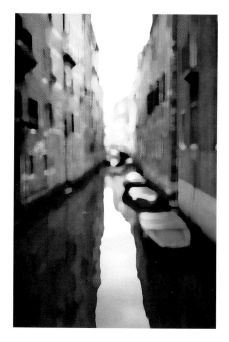

USING YOUR COMPUTER TO CHECK YOUR WORK

Doing it yourself will make it much easier to remember.

A very simple way of seeing tonal values is to change your subject into black, white and half-tones of gray using your computer. This is how to do it:

Photograph your completed painting using a digital camera or, if it is small enough, fit the work into your scanner. Copy to your appropriate File. Open Adobe Photoshop, Photo Deluxe (or similar program), open your image and convert it to Black and White or Halftone. You will readily see whether the values have worked in your painting because if they haven't, the black and white version will look even worse than the painting, where at least you had color to help you define shapes!

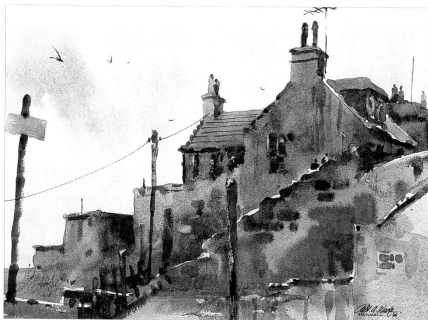

"Hillside, Macduff, Scotland", 11 x 14" (28 x 36cm)

LEARNING POINT

This is almost a two value painting — with the large mid value shapes of the buildings silhouetted against the light value sky. The dark post with the sign is extremely important because it balances the long diagonal and it stops the eye from sliding out of the picture. It was a day of fleeting clouds so the light was not too bright, thus keeping the contrasts down a tonal value or two.

"Comparing Notes, St. Thomas", 12 x 10" (31 x 25cm)

LEARNING POINT
Here is a very simple value pattern — dark and light. To make a statement it is not necessary to use every value or ten thousand colors! Remember the old cliché, "Less is More".

The more conversant you become with tonal values the more you will come to realize that you can engineer changes. Just because things are as they are, doesn't mean that they have to be painted that way. In fact, the more you are able to make changes in tonal value, the more personal your interpretation of the subject will be.

A TONAL VALUE TALE

I well remember in my very early days as an exhibiting artist, taking a painting to the Victorian Artists' Society for selection into a juried show. The wise old gentleman who took the painting from me remarked, "Ah, young fellow, rather a nice job but you have not yet recognized the extreme importance of Tonal Values. If you want to get on in this business I would advise you to pay special heed to the tones."

He was really indicating to me, in his polite way, that it was a pretty lousy painting, but the way he put it was more encouraging than critical. However, his advice was lost because I didn't actually understand what it was that he was telling me. I realize now how foolish I was not to have asked him what he meant. No doubt he would have showed me where I had gone wrong and I could have avoided a lot of heartbreak in future paintings.

The Bible's Book of Ecclesiastes states, "Better to be criticized by a wise man than praised by a fool". I bear that in mind every time I run a critique session at a workshop. (Could it be that they had watercolor workshops in Biblical times?)

LEARNING POINT
If you are attending a workshop and you don't understand something your Instructor has said, never hesitate to ask for clarification. The only dumb question is the one you don't ask. As famous golf teacher Harvey Penick wrote, "It's not what you say, but what the student hears, that is so important".

In this book it's not possible for you to ask me the question if there is something I have written that you don't understand, so I have to make sure my message is clear.

TONAL VALUES PROJECT

Take a subject with which you feel comfortable and experiment with it by painting it in as many different ways as you can, simply by changing the values. These paintings need not be larger than 6 x 4" (15 x 10cm), size is not that important. What is important, is that you understand that mastery of **TONAL VALUES** is the greatest asset any artist can have in both traditional reproduction and in the pursuit of individuality.

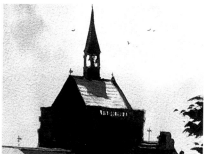

"Angles, Salat, France", 11 x 14" (28 x 36 cm)

SELF-ASSESSMENT CHECK

1 Examine some of your own paintings right now. Be critical of their values and determine whether you have succeeded in making the important shapes work, or whether your interpretation of the tonal values has let you down.

2 See if you have a good range of tonal values from very light to very dark.

3 Look closely at the edges of shapes and compare the relative tonal values. Is the value lighter? Is it darker? Is there a major difference — or is there a very subtle difference?

HOW CHANGING VALUES CAN CHANGE THE MOOD

Here are four versions of the same subject: Bonnie Doone Farmhouse, Victoria, Australia. See how I tackled this project, then paint this subject yourself.

Doing it yourself will make it much easier to remember.

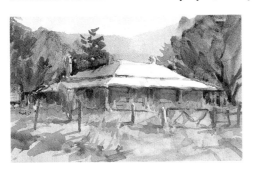

This version is okay, but it's nothing out of the ordinary
Here the white of the paper represents the lightest light tonal value and there are a few scattered darks. The final result is pleasant enough but it's nothing out of the ordinary.

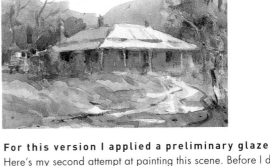

For this version I applied a preliminary glaze
Here's my second attempt at painting this scene. Before I did anything else, I applied a glaze of Raw Sienna and Aureolin over the entire background and allowed it to dry. Then I painted the same scene.

LEARNING POINT
The initial glaze took everything down a value and the result was a lovely glow. Because there was no white paper showing through the contrast is not quite as strong.

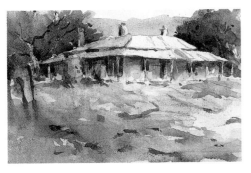

Using a stronger glaze
In this version of the same scene I used a stronger glaze of Raw Sienna, with just a touch of Permanent Rose, which took the light value down another step. The contrast is now a little less.

LEARNING POINT
Reducing the contrast between tonal values can result in a romantic mood that looks more painterly.

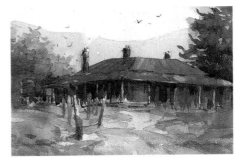

Another example of the same scene painted quite differently
A complete reversal. In this version of the same scene I transformed the light shape of the farmhouse into a dark shape that changes the mood once more.

LEARNING POINT
In this example I first applied a Cobalt Blue glaze, completely knocking out the white of the paper.

NOW IT'S YOUR TURN TO PAINT THIS SCENE

Once you are feeling confident with your interpretation of tonal values it's time to have a crack at putting your knowledge to work.

Bonnie Doone Farmhouse is a simple little subject and a good starting point for you to attempt a series where you can use values to enable you to achieve four different results from the one source.

Don't worry if you think your finished effort does not look like the subject, it doesn't matter. Remember this . . . YOU are the Director of this show and any time you want to change the values from the way that they actually are, then you certainly

can. You are not reporting the facts — you are making a painting, so the end result is all you need to worry about. If you should need to darken a value, or lighten it, in order to make the painting work, then it's OK, you are the Boss! You are able to make these changes because you now understand TONAL VALUES and their importance!

Although you are copying these examples I would like to think that after completing this project you will try the same approach with one of YOUR favorite subjects.

DO-IT-YOURSELF EXERCISE

SEE IF YOU CAN IDENTIFY THE TONAL VALUE PATTERNS

Doing it yourself will make it much easier to remember.

These photographs are all good examples of TONAL VALUE PATTERNS.

1 Squint and see if you can identify the value shapes.

2 Think in terms of dark, medium and light,

3 Then see if you can recreate them in three values of the same color.

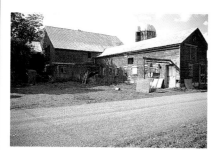
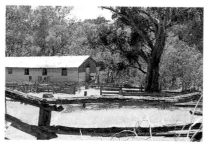
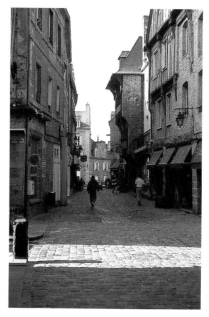

Wherever you have areas that are close in tonal value, allow the shapes to join. The exception is when, in your opinion, one of those shapes is relatively more important, in which case it will be necessary to change the tonal values a bit to exaggerate the contrast.

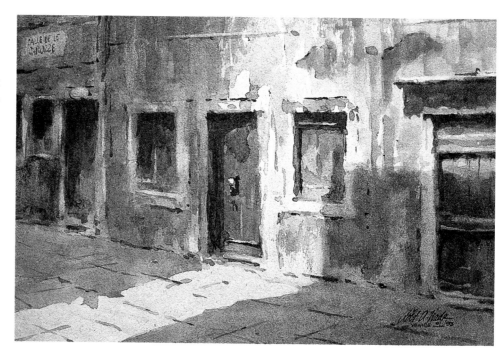

"Calle de la Carozze, Venice", 9 x 12" (23 x 31cm)

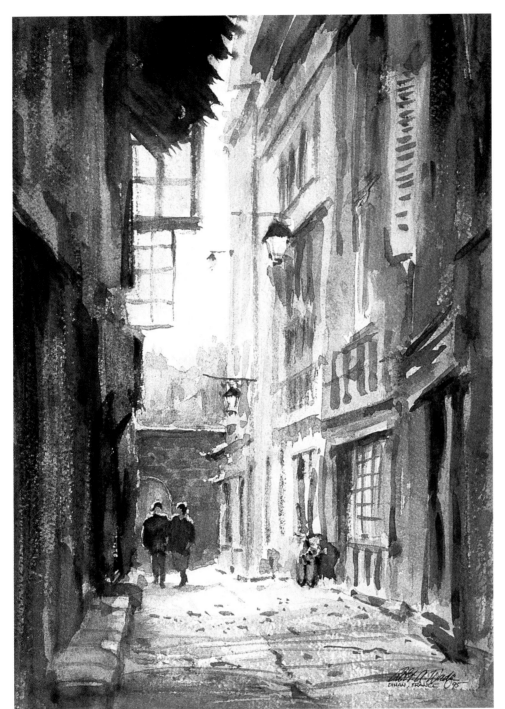

"Dinan Street, France",
14 x 11" (36 x 28cm)

LEARNING POINT
In this very moody little watercolor the values had to be spot on. The backlighting creates quite a theatrical feeling, and the halo of light on the heads and shoulders of the two figures lifts them out of the background.

All paintings do not have to go the whole hog and finish up with the Wham! Bam! "right between the eyes" contrast of the darkest dark and the lightest light. In other words, although using the black at one end of the range and the white at the other end of the range will result in dramatic and forceful paintings doing this does not always produce the most sensitive and appealing work.

ASSIGNMENT

NOW GO BACK AND START AGAIN
To ensure what I have said really is coming across, I recommend that you turn to the beginning of this chapter and read it over again, because tonal values are the key to your future development. Even if you are around to paint for another hundred years you will still be thinking TONAL VALUES at the end of it all!

One of the most important aspects of my way of working is how I apply my process of Visioneering. I'm never satisfied with representing a subject just as it is, I want to give my own interpretation of what's there and my reaction to it. In other words, I don't want to paint it how it looks, I want to paint it how it FEELS. Visioneering enables me to do just that. So let me explain.

VISIONEERING OUTDOORS AND IN THE STUDIO
SHOW ME HOW THAT WORKS

Visioneering is my way of seeing with my mind's eye. I conjure up feelings of how any subject could look if I were able to play God. I change from one season to another, I change the lighting conditions and the light direction, change the time of day, invent people, or add or eliminate any elements that could give me a better feeling for my subject. Visioneering allows me to see these changes and to assess their worth. I can visualize the Sahara under snow, Bermuda iced over, Buckingham Palace lined with palm trees and tropical growth, Times Square deserted except for a herd of wild elephants — or any other situation that I might care to envisage.

"I do not want to reproduce nature, I want to recreate it."
— Paul Cézanne

EXAMPLE

VISIONEERING IN ACTION

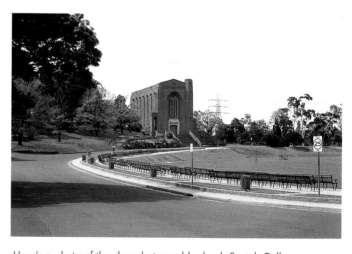

Here's a photo of the chapel at my old school, Scotch College. Because this is a very special place in my life, I wanted to give it a very special feeling.

My options are limitless, my mind runs riot in my own fantasy world.

I guess that I have had this overactive imagination all of my life, always revolving around two words — "What if?" When I begin each painting session I ask myself that question and when I've finished painting I ask myself once more, "What if?"

To begin with, my answers will be the visions I create that allow me to consider many possibilities for change. What if I painted a purple sky and red trees? What if I made it late afternoon instead of early morning? As I ask each question the process is like selecting another slide in a projector. I see a vision of my subject very clearly in my mind and my new way of viewing it.

When I think that I have arrived at the most sensitive feeling between my subject and myself, I know that Visioneering has worked and I can proceed with confidence and enthusiasm. The excitement grows as the painting progresses, resulting in a spontaneous reaction to the process of creation.

Maybe this process will be difficult for you at first. It's such a natural thing for me to do that I really can't explain it any clearer. Please try to allow your emotions to have full play. This is one of the foundations of my workshops — putting people in touch with themselves and understanding their emotional response to the hypothetical question, "What if?"

Now you can understand that Visioneering will give you the ability to portray one subject in many different ways. The actual scene before you is merely a starting point. From there it's possible to take the painting in many different directions.

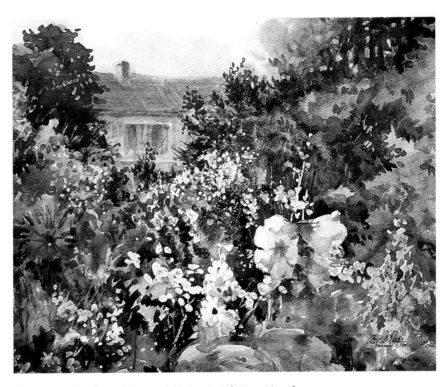

"Monet's Garden, Giverny", 14 x 16" (36 x 41cm)
We went to visit at the wrong time of the year. Monet's Garden was bare! Not to worry — I called on Visioneering and just invented the blooms.

The light passage I saw in my Visioneering would allow me to do that. Here are the first mainly soft edged big shapes. Some refining here but not too much detail.

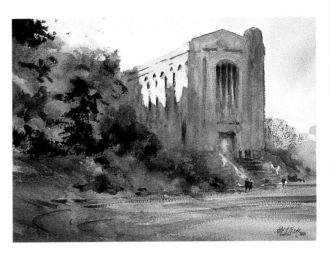

"The Chapel, Scotch College", 11 x 14" (28 x 36cm)
I think the finished painting has rather an ethereal mood. Compare this with the scene photo.

EXAMPLE

3

VISIONEERING & DRAWING

This flower stall in Taunton, Somerset, appealed to me as a future painting subject.

I Visioneered a few things. Most of the flowers just happened as I painted. I popped in another vague figure and that worked. I like the romantic couple with arms around each other, which adds a bit of mystery . . . has he just purchased a red rose for her? **"Flower Stall", 18 x 24" (46 x 61cm)**

. . . this is our show, not the camera's. The camera records the facts and details, we present the essence — the heart and the soul.

"Summer at Koroit, Victoria", 11 x 14" (28 x 36cm)
A glaze of Raw Sienna and Winsor Violet over the entire surface set the mood for the subject.

"Winter Light, Koroit", 11 x 14" (28 x 36cm)
A fun subject to play around with. Visioneering allow us to change to any set of conditions we choose.

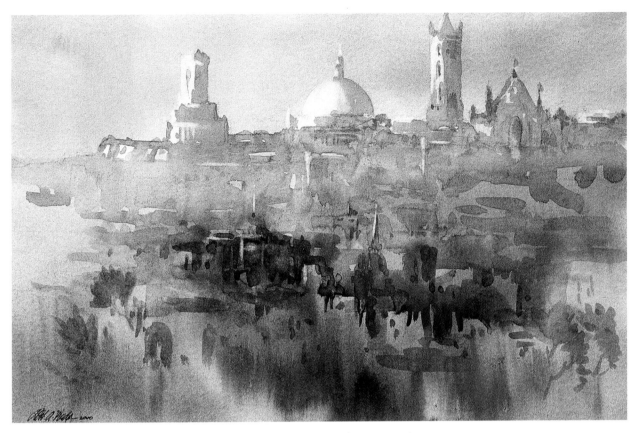

"Siena Remembered", 12 x 18" (31 x 46cm)
Siena was so busy that we could not find a spot to set up our group of 35 without upsetting the traffic.
This class demo was painted later, back at our hotel. I had a very quick pen sketch of the skyline for
reference and then the rest came from my Visioneering mode.

"Purple Cattle, Koroit", 14 x 21" (36 x 53cm)
Purple? Red? Green? Why not! As long as the values are right, then you can just let your
imagination run riot.

VISIONEERING ON SITE
ADVICE FOR THE OUTDOOR ARTIST

Let's look at the tried-and-true methods of on-site painting. I don't think the basic principles have changed much since Turner, Cotman, Cox and Bonington set out with their easels for a day's fun in the country. The equipment certainly has improved, and working methods differ, but the same principles of TONAL VALUES, PATTERNS and BALANCE remain the same. The joys experienced by the on-site painters of yesteryear and those who brave the elements today are unaltered by time. Nothing compares with being at one with nature, feeling the breeze, hearing the birds, smelling the earth and trying to communicate that joy through the watercolor paper on your easel.

At the beginning of each workshop day I always read poetry to my group to heighten their emotions and their personal reactions to the surroundings. I read many of the poems of Judith Viorst, the fun poems of Jack Prelutsky, Shel Silverstein and others, as well as a wonderful little childrens book, "Frederick", by Leo Lionni.

Several years ago I arrived at Port Clyde for my annual workshop but somehow along the way I had picked up conjunctivitis on the long flight from Australia. I could hardly see but, thanks to an after-hours visit to a very caring opthalmologist, Dr. Bob Dreher, the problem was diagnosed and treated. When Bob had completed his examination of my eyes, I asked him if I could pay him with a travelers cheque. "No", he said, "I'd be happy if you would just sign this for me". He produced a copy of one of my videos, which I was delighted to sign! Bob paints in watercolor too, which goes to show you that you never know when the subject of watercolor will crop up.

However, my students were very concerned about my vision, and each day they would make inquiries about my progress. One morning I replied, "Not too bad, but come tomorrow I'll be fine". The phrase immediately struck a chord with me, so I wrote the following poem as a result.

The whole thing was from my imagination, but I projected myself into the scene, with the result that despite the fact that I have recited it hundreds of times, I always feel quite choked up every time I read it.

THE BOTTOM LINE

You've gone! You swore that you never would.

You've gone! I just believed that you never could.

Right now I'm standing here alone it feels my whole life's turned to stone.

I guess it's called The Bottom Line.

But, come tomorrow, I'll be fine.

Days are dark, nights are long, the sun has lost its shine.

At least that's how it seems to me, since you're no longer mine.

There is no light, there is no sound, they only happen when you're around.

Still, the thing I've always found, somehow I've managed to rebound.

THE PAINTING FRAME OF MIND

How do we go about the task of finding something decent to paint, something that excites us and engenders a sympathetic response in our artist's heart? Attitude is so important. The proper frame of mind will start you off on the right track. Here's an example of the wrong mindset:

"I'm out for a day's painting and today I'll get me a Gold Medal winner."

Wrong! With this thought in mind, it will never be possible to find a subject that comes anywhere near your lofty expectations. What will surely happen is that you will arrive at your destination, wander around until lunch-time and still be no closer to discovering that elusive award-winning subject. By mid afternoon, you'll be so frustrated because you've achieved nothing that you'll settle down to paint any old thing and it will turn out badly. There's only one thing left to do then — pack up and go home mad.

The correct attitude is to set out with the express idea of having FUN:

"Oh boy! what a bonus to be here in the great outdoors, I can hardly wait to splash some color around and see what I can make of this place."

So with no high hopes for anything other than the thought of having a good time, a positive attitude is set and the resulting painting, be it good, fair or bad, will show the world that you had FUN. There is a better than even chance that the painting will be a good one because it has been performed with spontaneous enthusiasm, and it could even be the beginning of a finished studio statement.

Today I'm at The Bottom Line,
but, come tomorrow, I'll be fine.

Another day. Another night.
Another wish, perhaps you might?
Another week, another year
and down my cheek another tear.
I miss the warmth of your embrace,
I'm almost haunted by your face.
It's something that I can't replace.
I guess I'm just a hopeless case.
Today I'm at The Bottom Line
but, come tomorrow, I'll be fine.

PAINTERS MAKE SILENT POETRY

The poet uses words to express emotion. We painters don't have words to convey feelings in our paintings, just our brushes, so we must remember that what we are producing is "silent poetry". If emotion is absent from our work, then we might just as well record the scene with a camera.

Our vision is so important to us, and sometimes we do not appreciate just how critical it is. After having undergone cataract surgery on my right eye some years back, things went horribly wrong. For the next two-and-a-half years I had double, and even triple vision in that eye! Eventually, another operation corrected the problem and, miraculously, my vision is now 20/20 again. I can't tell you how much an incident like that makes one appreciate the wonder of sight, but even more than that, the wonder of an artist's VISION.

In judging and jurying shows around the world I'm struck by the number of "non-feeling" paintings that I view. Many of them are almost technically perfect, but as for emotion — zilch. These paintings are very clever but how can these artists know so much, yet feel so little? After reading this book, please hear my request for more emotion and sensitivity in your work. Look at John Singer Sargent's works and just feel the involvement he had with every watercolor he painted. That's what real art is all about. Don't believe all the nonsense that's thrown at us today in the name of art, most of it is a sham. Someone once said, "Painting is the art of protecting flat surfaces from the weather and exposing them to the critics". It seems the more outrageous, the more controversial the work is, the more it is praised by the critics. In turn the critics write critiques that we mere mortals cannot understand, and the more obtuse, the more unintelligible the critique, the more secure these people become in their jobs. I think it was Oscar Wilde who said, "Asking artists what they think of critics, is like asking lamp-posts what they think of dogs".

Well, let's get back to business before I really explode. In fact that's almost spoiled our day out painting. So, let's whistle a happy tune, take a few deep breaths of this balmy air, knock some ants from our shoes and some leaves from our palette and settle down ready to go again.

LOOK FOR A GOOD VALUE PATTERN

Discovering a good subject is not all that easy so if a grand vista is not immediately obvious, forget that approach. Instead, think in terms of a good value pattern — look for the big shapes and a balance between light, mid-value and dark. Some of the most uninspiring subjects have become award-winning paintings for me because I've had to think, feel and work harder to inject something of myself into that situation.

Good watercolors are visual poetry; word pictures translated into color images that sing, or sob, as they stir the emotions of the viewer.

WAYS OF WORKING ON SITE

1. MULTIPLY YOUR PAINTING OPTIONS BY DIVIDING YOUR SHEETS

Many years ago, American watercolorist Charles Reid showed me how he prepared for painting in an unfamiliar area. He painted three or four simple sketches on a half-sheet, just to discover how he felt about the location. At the time we were painting in Taxco, Mexico, and I soon discovered that his advice suited me, too.

From that beginning in 1982, I have developed an exercise called "divided sheets". These are purely exploratory studies — you must not be tempted to produce finished paintings. These studies help to crystallize your feelings and reactions to a new situation.

On site, Guanzhou (Canton) China
My group was scattered at this point and each one had a crowd of very polite local onlookers. I was working on a divided sheet. You can see what I produced on the facing page.

DO-IT-YOURSELF EXERCISE

DIVIDED SHEETS

Doing it yourself will make it much easier to remember.

Here's how to do it:

1 Tape your half-sheet to the board.

2 Then tape off four or five different size rectangles within that sheet.

3 Make the divisions uneven in size for the most interesting result, but don't have any preconceived ideas of what you're going to put in the spaces. This is very good discipline and forces you to be creative in your choice of subjects and shapes.

4 Paint the sheets quite quickly. I usually allow no more than one hour for a completed sheet of five. Avoid detail, keep them simple, have fun.

This is an excellent way of sorting out your feelings for a new place so that you can make some decisions about what and how you will paint your actual watercolor when you get around to it, maybe the next day. These sketches will be great memories of wherever you are, and will serve as reference for future studio paintings when you return home.

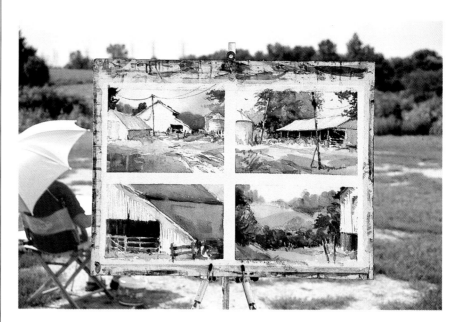

Divided sheet done at Bartonville, Illinois

REMEMBER: no pattern, no painting.

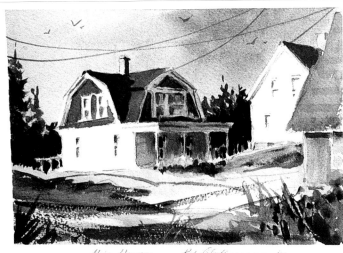

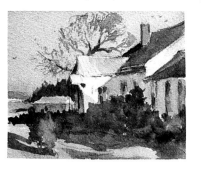

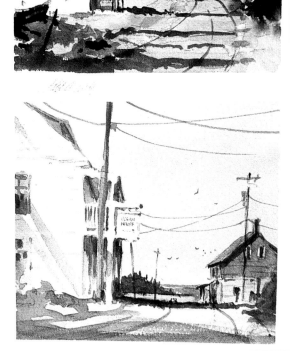

My divided sheet done at Port Clyde, Maine

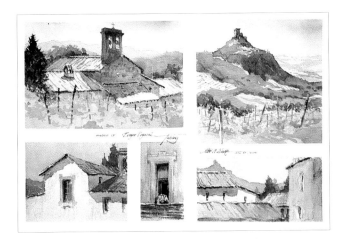

Divided sheet done at Bagno Vignoni, Italy

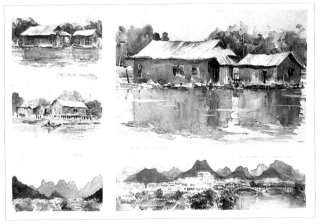

Divided sheet done on site at Guanzhou

The most important factor in watercolor painting
is the white of the paper, so you must preserve
that light passage at all costs.

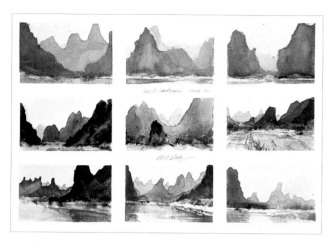

On this page you'll see other examples of divided sheets painted in different countries. This one was done in Guilin, China

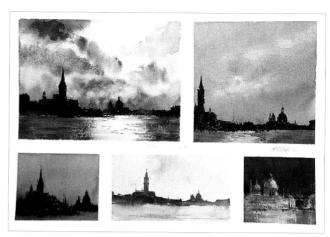

Venice — It was a clear blue sky that day, but who could paint Venice that way! Each of these little sketches was an exercise in Visioneering. Opposite you'll see one of the paintings generated from these ideas.

What works in China works just as well in Swerford, Oxfordshire . . .

. . . Sedona, Arizona . . .

. . . Bermuda . . .

. . . and Albi, France

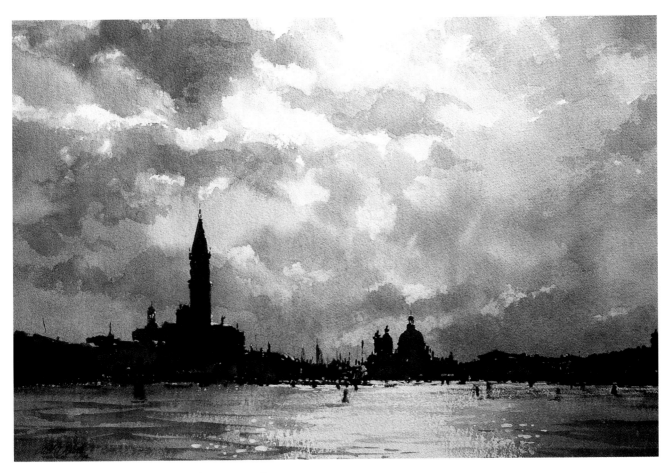

"Clouds over Venice", 14 x 21" (36 x 53cm)
I did this painting from the references on the divided sheet shown on page 40.
The painting is in the Permanent Collection of the Brooklyn Museum.

CASE STUDY

WORKING WITH A TIME LIMIT

"Albi, France", 14 x 21" (36 x 53cm)
I had imposed a strict time limit for my workshop class in order to get them to free up a bit, not to overdraw, not to overpaint. To show them how it worked, for this class demonstration I allowed myself 20 minutes from go to whoa! The initial drawing took 25 seconds, and I merely indicated the major shapes.

I had been painting for only five minutes when we saw a storm approaching. I packed up and we all hightailed it to a dry spot under the Albi bridge. I set up again but was unable to see the subject, so I painted it from memory. I completed the demo in exactly 20 minutes! Set some time limits for yourself occasionally, it's good for you. HOWEVER, YOU MUST BE HONEST!

WAYS OF WORKING ON SITE

2. DEVELOP YOUR POWERS OF OBSERVATION BY MAKING SKETCHES

Another fun way of working on site is the traditional sketchbook method. I can't recommend a better way to develop your powers of observation and your drawing skills. This is also a super way of recording your travels, and I must admit that I like nothing better than looking through other artists' sketchbooks. It's amazing how loose some people become in their sketchbook drawing simply because they have a carefree approach and don't become locked down in trying to make finished works.

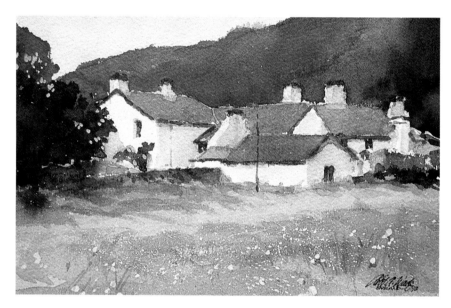

**"White Walls, Windermere, UK",
8 x 10" (20 x 25cm)**
Values are obvious as the interesting pattern of the light shapes is contrasted by darker shapes. This was a very fast sketch; that's what watercolor was meant to do.

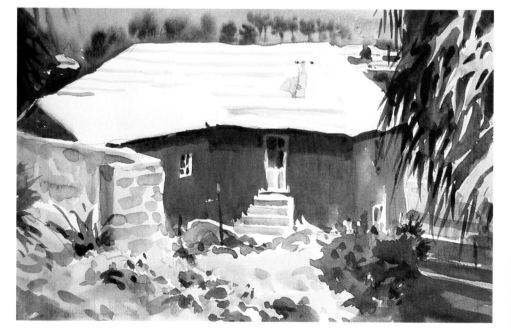

**"The Bermudian",
8 x 10" (20 x 25cm)**
Great color! The simple shapes make a super pattern and no superfluous detail is included.

EQUIPMENT

Sketchbooks

Sketchbooks come in a multitude of sizes and colors. I prefer the spiral-bound type instead of the normal binding which seems to be a bit brittle, cracks, breaks and then pages may drop out from the book.

Pens

I think that the nylon-tipped pens of today are great instruments for sketchbook drawing. If you use the permanent ink type, the drawings will never fade, and if the ink is also waterproof, then you can put a wash of watercolor over the drawing at some later stage, should you desire.

Pencils

Pencils are really my favorite drawing tools, but if they are used in sketchbooks then they will usually suffer from rubbing with the action of moving sheets and after some years can become smudged until they are almost useless. Pencil sketches can be sprayed with fixative to preserve them but if if you don't make that effort quickly enough you will have a problem.

Charcoal

Charcoal is a wonderfully responsive tool, but hopeless for sketchbooks — what a mess! I only use it in the studio for value studies or for finished figure drawings, and then I can't wait to wash my hands. It can be used for preliminary drawing for your watercolor. Quite a lot of charcoal will come off with the wash and some will float into areas where you prefer it not to be, but it is worth having a try just for fun — but in the studio rather than on-site.

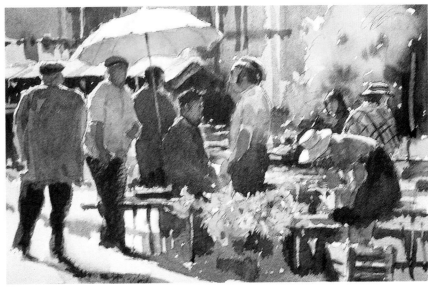

"Flower Market, Caldas da Rainha, Portugal", 7 x 9" (18 x 23cm)
A happy, small sketch which is all about the passage of light — and all done in 30 minutes.

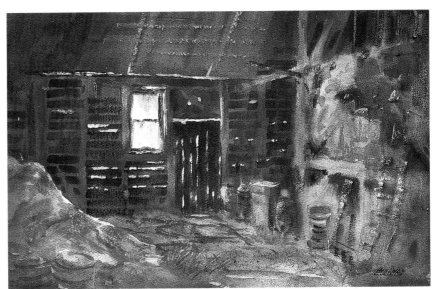

"Skidmore's Barn, Greenvile NY", 14 x 21" (36 x 53cm)
I had painted this great old barn many times . . . from the OUTSIDE. Just for a change, and in order to get my class out of the hot summer sun, this time I went INSIDE to paint this demonstration. The values had to be spot on. Good fun!

Once you draw or sketch a subject it will stay in your memory forever. I'm sure that you have had the experience of trying to remember where you were after looking at newly processed photos following a vacation or trip. Some of them you'll not even remember taking. Not so with a sketchbook, it will be etched into your memory forever.

WAYS OF WORKING ON SITE

3. TAKE A LINE FOR A WALK WITH CONTOUR DRAWING

Contour drawing is a very creative way of drawing, and nobody does it better than my dear friend Charles Reid. He explains his method very clearly in "Flower Painting in Watercolor", a Watson Guptill book.

The basis of contour drawing is to leave the point of your drawing instrument on the paper and then "take a line for a walk". Because you never leave the paper you are forced to join shapes, so connections are constantly being made between all the shapes in your drawing.

Contour drawing is particularly effective as a preliminary drawing for your watercolor because it will help you to avoid "the fill in between the lines" type of painting.

The unwritten rule says that you leave the point on the paper, but look at the subject not the paper. Working this way makes you feel as though your point is actually resting on the outline of the subject and you allow it to travel around that shape, consequently transferring the image to the paper. This method is extremely successful. Alternatively, you can do as I do — I prefer to watch my paper, as in the traditional drawing method, but I never lift the pencil from the paper.

I have a little pencil called "The Shorty", which I discovered in an art store in Venice. It's only 4" long with a very thick lead. It fits across the palm of my hand, has a great feel and helps to give a loose, sketchy result. (I think it's called a "Stumpy" in the USA.)

Whatever tool you use, allow it to skip across in between shapes endeavoring to capture the ESSENCE of what's there before you — never trying to make a finished architectural or geometrical representation of your subject.

My "shorty" propelling pencil.

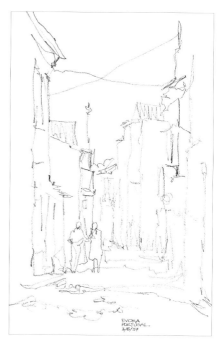

Here's an example of a contour drawing.

ASSIGNMENT

PRACTICE YOUR DRAWING AT EVERY OPPORTUNITY

This is NOT an instruction on drawing for drawing's sake but a recommended direction to take for the watercolor painter. The better you can draw then the better you will paint. Forget all the junk that you hear about "you don't need to draw, just express yourself in your own way". Baloney! That belief is the underlying cause for some of the dreadful paintings being produced today right around the world. Drawing is the basis of every form of good art, from sculpture to sketches, from pastel to portraits.

Do not neglect your drawing skills. Draw whenever you can and whatever is there before you.

WARNING!

Do not OVERDRAW as a preparation for your painting. A technically perfect drawing is a big YAWN. I'd sooner see a drawing which is not a hundred per cent correct, but which has verve and life, than an architectural rendering totally devoid of feeling. Should I ever see any of my students spending more than half-an-hour on preliminary drawing, I know right away what's going to happen — the drawing becomes too precious to the student because it's taken an hour or so to produce, and the resulting thought will be "Oh Oh!, I must not ruin this lovely drawing".

3

VISIONEERING & DRAWING

4. BE VERY BRITISH WITH LINE AND WASH

A very British way of painting loose sketches is the line and wash method. Artists like James Fletcher-Watson, and the late Edward Wesson, worked that way occasionally, producing work of great charm and movement. I can't recall ever having seen much line and wash work done in that way in the USA. Maybe you might like to give it a try.

Materials required are suitable papers and pens. Cold-Press surface is good, Hot Press is even better, but it would be wise to test your sheet before you work on it. A wide variety of tools can be used. Wesson often used sharpened twigs with drawing ink. This is a fine way to work, as the lines produced are broken and uneven, perhaps a little out of control, which prevents "architectural drawing syndrome". Bamboo and reeds, the wooden stick from chocolate-coated ice creams, matches, and even the handles of old brushes will work when sharpened. Twigs and matches can be inserted into Grifhold-type knife handles to give a stronger feel if required. Nylon tipped pens are fine, and fountain pens and dip pens are also satisfactory.

IT IS ESSENTIAL TO USE WATERPROOF INK SO THAT IT WON'T RUN OR DISSOLVE WHEN WASHES ARE APPLIED OVER THE LINES.

Once again, test your materials before ever using them.

There are two ways of tackling this method of working.

1. It's possible to start with loose washes and, when dry, work over them with a pen drawing.
2. The other way, which I prefer, is to start with the free pen drawing and then apply the washes.

Whichever way you decide to go, it's important that the entire effect is one of slightly "out of register" line work, so that it overlaps some shapes, stops short of others and leaves a gap between others. This is what produces such a pleasant random effect and it seems to please many viewers. I think it's important to make the line dominant and the washes supportive. The most critical pointer to success is to avoid drawing straight lines because they are boring. Let the lines waver, change weight and hit-and-miss. These will become painting lines with CHARACTER.

"The Queen's Guards, Royals and Blues", pen and wash
Joining the guards and horses into one big shape simplified an otherwise daunting subject.

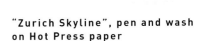

"Zurich Skyline", pen and wash on Hot Press paper

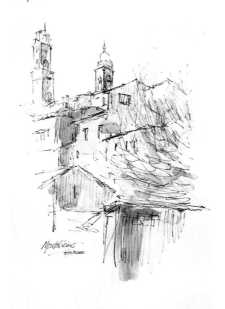

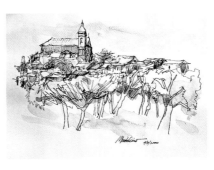

Felt pen and wash, Montalcino, Italy
Notice that the wash is very pale and does not overpower the line

Pen and wash sketch, Portugal

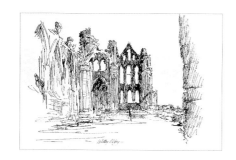

"Chioggia"
A brush pen is another interesting tool. Try it.

CASE STUDY

PEN AND WASH IN ACTION

**"St. Mary's, Bristol",
11 x 13" (28 x 33cm)**
A detailed pen drawing on
Cold-Pressed paper.

A free application of washes gives a
very attractive result. Notice there is no
painting between the lines!

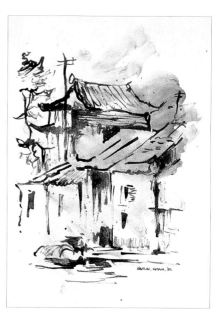

**Drawn with sharpened wooden ice
cream stick and waterproof ink**
The sketchbook had a loose wash put down
on the pages before I went into the field.

OUTDOOR EQUIPMENT

As far as outdoor equipment is concerned my advice is to travel light. Usually there is a bit of a walk to get from the car park to a site and it's surprising how heavy your gear can become, so leave the kitchen sink at home. My pack is as basic as possible.

I have a Stanrite Boutique (USA) aluminium folding easel. This is extremely light, fully adjustable for angle and for drawing board size. It also has a brace between the legs of the tripod which will support a piece of chipboard. This becomes a shelf

for my palette, water containers, box of tissues and brush holder. I find this to be a great help. All of this material folds down and fits in my great old Moroccan carpetbag, which has a strong shoulder strap. My drawing board, chipboard shelf and sheets of paper pack into my folio, which also has a shoulder strap, so I can have one bag hanging on each shoulder keeping me nicely balanced for the walk to and from the site, and leaving both hands free. Have fun!

My entire outdoor equipment on site

GETTING DOWN TO PAINTING ON SITE

Here is the ultimate enjoyment of painting. To find your own little spot and commune with nature, to put down on paper your personal reaction to the subject and not give a darn what anyone else thinks about it, or you. Not a critic in sight but, sooner or later, the inevitable onlooker will notice you. Curiosity getting the better of him, he'll saunter over and cast his "experienced eye" over your work. Usually there'll be a comment like, "used to be pretty good at that myself when I was at school". This is said in a way that implies that if he'd wanted to pursue art as a career he'd be far better at it than you! A solution to this problem is to simply take off your hat and drop it on the ground, upside down, inviting a charitable contribution — this usually deters even the boldest pest.

But not all encounters are annoying. I remember one funny incident when painting on the banks of the Vletava River in Prague. I was having a great morning and the painting was working out rather well. All morning there had been a fairly constant passing parade of locals. I had absolutely no idea what they were saying. Suddenly a very Australian voice said, "Hey Bill! Come and have a look at this bloke, he's not bad". So Bill came over and the two proceeded to discuss my work, believing me to be one of the locals. I listened to them with some amusement until I felt that they were about to move away. Turning to look at them, I said, "G'day fellas, heard any football scores from home?" Well, the looks of surprise were something to see, and we all burst into laughter. I joined them for lunch at a local café some time later.

COURTESY AND SAFETY

When you are on site, two matters of paramount importance must be observed: courtesy and safety. Ensure that the place on which you have selected to erect your easel is not somebody's private property, that you are not blocking a pathway, not obstructing an entrance to a property or causing any problems to locals. I have only been refused permission to paint on a selected site on a couple of rare occasions. I think most people feel that there is no danger from artists, considering us to be simple, humble people who will not harm the environment or cause any problems.

It's only good manners to request permission from the occupants of the property. The unbreakable rule is CLEAN UP. Leave the property as you found it or even cleaner.

The other matter is safety, both yours and other people's. If you are working in a public place do not spread your gear around where passers-by can trip and fall. Ensure that your easel's legs are similarly safe and out of the way. Consider your own safety. If you are painting on the coast be aware of the tides, ensure that your spot on the edge of a cliff or on slippery rocks will not cause you a problem. It's so easy to become entirely absorbed in the scenery and forget to watch where you are walking. I speak with some feeling because I have had a few very heavy falls myself. One I particularly remember was in Scotland where I was so completely fascinated with the beauty of the Firth that I slipped on the seaweed-covered rocks. Not only was my body bruised and sore but my camera came down with a crash, smashing a lens and costing me some hundreds of dollars to repair. TAKE CARE!!

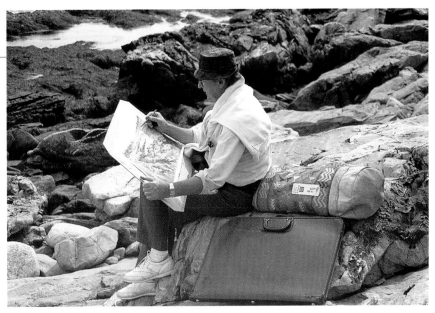

If you are properly kitted out, painting on site can be extremely pleasurable

My trusty old Moroccon carpetbag and folio

My aluminium folding easel in action

VISIONEERING IN THE STUDIO
ADVICE FOR THE INDOOR ARTIST

3
VISIONEERING & DRAWING

"Venetian Facade, Venice", 14 x 21" (36 x 53cm)
The patina of time is evident everywhere in this wondrous city and I attempted to get this feeling when I returned to my studio in Australia. The water was eating away at the foundations and one wondered how long could it last? This watercolor won a major award in the *Grand Prix D'Aquarelle* in Trégastel, France.

"Corner of San Gimignano, Italy", 14 x 21" (36 x 53cm)
The figures are paramount to the success of this painting, but they had to appear to be moving and animated. Static figures would not have indicated the bustle of the shoppers that I wanted to capture.

Indoor painting is a quite different kettle of fish from painting on site. In the studio, the time parameters are different. You don't have to impose a time limit before (a) the light goes, (b) it rains, (c) the tour bus departs, or any other funny old reason.

In the studio there is more time to prepare, to plan and to think.

Procedures and working methods are really quite different from working on-site but I think that they go hand-in-hand as part of the artist's life. For me, the outdoor part is fun and the studio part is serious work. Don't let me give you the impression that this is tedious and dull, it certainly is not. Here is the culmination of an artist's learning, experience and skill — where the more difficult subjects are tackled, where experimentation is possible, where the gallery and exhibition pieces are produced. These days I estimate that 80% of my time is spent in my studio. Much of that time is not spent actually painting pictures but there is much time spent planning and writing magazine articles (and this book too).

STUDIO PROCEDURES

I have already covered lighting and equipment in the "Materials" chapter but I would like to discuss procedures. My working week is planned carefully. I have a list that has my schedule for the whole month. It is changed constantly as the need arises but it has all of my commitments right there, day by day. I know, for instance, if I need to paint six half-sheets for a gallery and they are required by a certain date. I must schedule those works to be painted two weeks before the due date in order to give my framer enough time to do his job on time. I will need to plan my time to allow me to paint at least eight

half-sheets so that I can select the best six, just in case there are a couple which don't quite measure up to my standards.

My working day begins at 8.00 am or earlier and finishes somewhere about 6.30 pm (which is really too long for an old bloke!), but unless I organize myself this way I will never be able to fulfill my commitments.

To return to the target of the six hypothetical paintings. Although I would have allotted the painting time on my schedule sheet, it would not be a matter of starting the day by taping down a sheet and then beginning work on the watercolors. Long before the actual painting begins I will have stepped into Visioneering mode and planned the six paintings, what the subjects will be, how I want to portray the mood, which paper I'll use and in which sequence I'll paint them. I will have mentally painted them half-a-dozen times in preparation for the actual production. This happens while I'm sitting by the TV lost in my own dreams, or perhaps before I drop off to sleep at night. By the time I'm ready to begin, I will have painted a value study for each subject, and maybe there could have been two or three sketches in the preparation process as well. In other words, it's not a hit-or-miss procedure but a planned professional progression from idea to completion. Like a professional musician or sportsman, there is far more before the event than during the performance itself. It's only through this amount of dedicated practice that we can each give of our best at the time when it's required.

THE PAINTING PROCESS

Now let us look at the actual painting procedures. My reference source for these mythical watercolors may come

Stall near Beijing
I photographed the scene from our bus, which was on its way to the Great Wall. I always have my camera at the ready, set at 1/500th of a second and, I have taken some terrific subjects in this way.

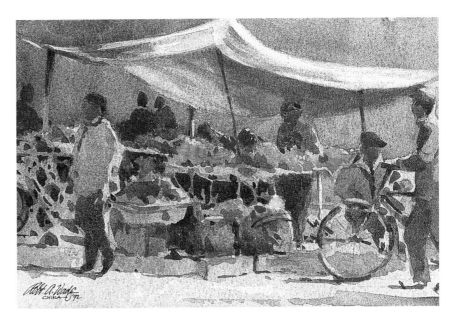

"Market Stall, Beijing", 7 x 9" (18 x 23cm)
This small study was painted back home some months later. Please compare it with the photo . . . IT IS NOT A COPY! Look and see how I have used just the elements that attracted me and moved them around to make my statement. This is how photography must be used, as reference, not to copy!

Studio painting allows the artist to restore life to a painting that's almost dead.

"Morning, Guilin, China", 18 x 24" (46 x 61cm)
The figures were invented but I had a good store of reference in my head from all of the sketching which I did on our journey to China. Notice how important the highlights are on the shoulders.

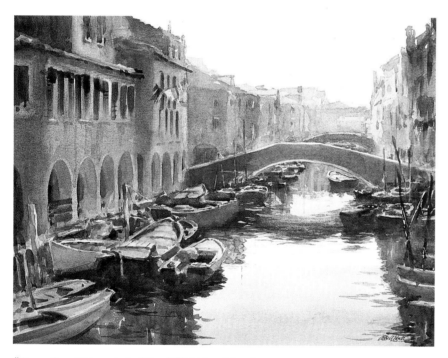

"Gray Day Chioggia", 19 x 29" (48 x 74cm)
Another change of tempo! Instead of portraying the scene the way it was (bright and sunny), I visioneered this moody, dull morning. I used very subtle values and eliminated much of the detail in the distance behind the bridge.

from my sketchbooks, on-site paintings, memory, imagination, divided sheets or color slides. The source will never be from photographic prints. I find that the small images from small photographic prints make me think small and I just clam up. If I'm using slides then it's a different matter. I can project the image onto my studio wall and enlarge it up to at least 6 x 4' (180 x 120cm) so that it's almost like being back there on the spot. We'll just imagine that this is what is happening, and I'll go through my procedure with you.

- In normal daylight the projected image will be slightly diffused from the light coming through the windows and that's just how I want it. I don't want sharp, hard-edged images, all I'm after is a reference point and I'll develop the subject from there.

- I will sit away from the image, say 15 feet back, run through five or six slides and select elements from them if they appeal to me.

- After the selection has been finalized then I'll just sit back and draw from the reference images. I'll take a bit from this one, a bit from that one, maybe invent a figure or two until, eventually, I've arrived at what seems to me to be a pleasing balance.

- The projector is then switched off and I do a couple of small 6 x 4" (15 x 10cm) sketches to determine how I will represent the light, color and mood. Then a value study to ensure that the pattern is OK and that I've worked out the contrasts that best suit the selected shapes in the work. That's the full extent of the camera's influence, because from then I will decide the colors and the mood — this is my show not the camera's. The camera

records the facts and details, we present the essence, the heart and the soul. John Ruskin said, "Fine art is that in which the hand, head and heart of man go together".

- All that remains is to paint the watercolor. I am fully prepared, I have given myself every chance of succeeding. If I fail it won't be for the lack of thought or preparation. REMEMBER, BY FAILING TO PLAN, YOU ARE PLANNING TO FAIL!

- The finished watercolor may not bear much resemblance to the actual reference slides and that's the way I want it to be. Anyone can use a camera but it takes something special to do what we do! What I'm really saying to you is this: DO NOT COPY PHOTOGRAPHS. Use them for reference only and then inject your personality into the subject. Only use photos if you could still paint without the aid of the camera, don't let it become your crutch, let it be your servant to use as you determine.

I have well over 70,000 color slides, resulting from 30 years of travel, and they are all stored in slide magazines so that I know just where I can find one within minutes. A system is essential otherwise it would be quite hopeless to try to discover a slide's whereabouts. Fortunately, I'm possessed of a very good memory too and I can remember which trip and which year I took the slide I'm seeking — that helps a lot.

Studio painting allows the artists to restore life to a painting that's almost dead. On-site it's only possible to render first aid to the work, but in the studio there is every facility at hand to assist in the resurrection!

"Waiting for the Master, Sligo Ireland", 18 x 24" (46 x 61cm)
I have to admit that I like painting pictures that tell a story. The setting . . . a misty Irish morning, the players . . . some straggling sheep, the shepherd and the sheepdog. Can't you feel the bond between man and dog? If the dear old dog could only talk he'd have an "Oirish" accent!

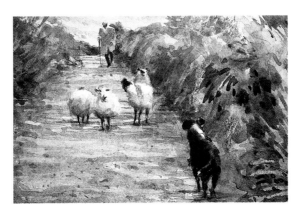

Detail
Those shapes are confidence tricks, there is no detail there at all!

51

VISIONEERING DEMONSTRATED

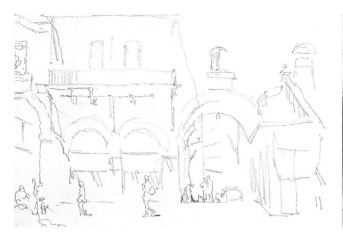

"Cortona, Italy", 14 x 21" (36 x 53cm)
My taped sheet of Waterford Rough with loose drawing of the major elements. It took about ten minutes to get to this stage.

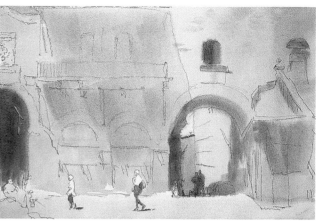

First washes
Big, light valued, soft edged shapes.

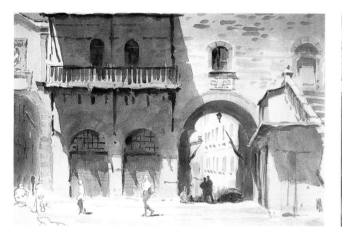

Definition begins
I stated a few mid-value darks to give me something to act as a yardstick.

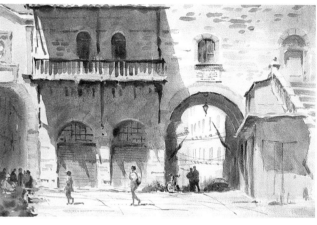

"Saturday in Cortona, Italy", 14 x 21" (36 x 53cm)
The finished job, see how the light bounce in the cast shadows makes those areas sing. The dark silhouetted figures beneath the arch are extremely important to this scene.

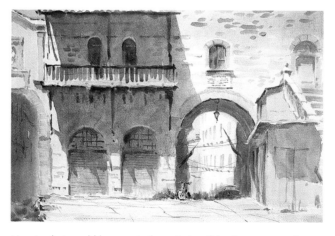

Here's what would happen to the painting if the figures weren't there. Not as effective is it?

VISIONEERING BY COMPUTER

Having come to grips with the general principal of Visioneering, we will now come to the high-tech side of things and see how the computer may assist those who are not able to use their imaginations as actively as others.

Here's a way that helps students to see in a physical sense, if they are unable to see the visions in their mind. It needs a computer plus a software program like Adobe Photoshop. In principle, I am totally opposed to computerised art, since it is a quasi-mechanical form of expression, completely devoid of emotion and personality. However, if this suggestion I'm about to offer enables you to see things in a different way, then I suppose it's OK. Even so, when you achieve your result on the screen you must still interpret the effect to give a painting that contains more of you than the computer.

1. Select a photograph or slide of a subject that appeals to you as a possible painting subject.
2. Scan the image as a bitmap and Save in a selected file.
3. Open Photoshop. Then open your bitmap image. Select Filter and from the drop down menu go to Artistic then select Paint Daubs. Your image will then appear as a very impressionistic rendering with big brush strokes. This may help you to understand where the values are. It is possible to play with the image at this stage or before you apply the paint daubs.
4. When you have opened the bitmap image in Photoshop, go to Image, Adjust, select Variations and you'll be able to change the colors in a matter of seconds.

It's a bit of fun at any rate but don't become hooked on the computer idea.

Although I've had quite a few computers over the last 12 years or so, never yet have I used any of these little tricks to work out how I want to Visioneer my image. However, I really don't know how I'd exist without my computer in the studio these days, but it's as a word processor that I find it most useful. Constantly writing magazine articles, sending letters and invoices, preparing submissions and printing out workshop information handouts, the convenience of having this professional looking facility right on hand is marvelous. E-mail is the other wonderful feature of today, keeping me in constant touch with friends and students from one part of the globe to the other. However, keep computer-manipulated images where they belong — in the computer.

One of the most expressive means at your disposal is the way you use color. In this section we'll look at paint handling, color mixing and working with a limited palette. Then I'll show you how to reinforce the mood of your painting with glazes. So, buckle up for the next big adventure!

COLOR & GLAZING
SHOW ME HOW THAT WORKS

4

COLOR & GLAZING

"I am not interested in color for color's sake and light for light's sake. I am interested in them as a means of expression".
— Robert Henri

As a general rule, I do not think enough time is given in art instruction to the business of mixing colors. If you don't know which color to put with which color, then you're really in a great deal of trouble! It's like being thrown into the deep end and being told to swim. Nobody can tell you just how you want to mix the colors that you need for your own painting, but you CAN be put in the right direction.

I've already given you my colors and where the colors are placed on my palette so now we need to address the procedure of "this goes with that". You MUST know the properties of each and every color you use. You must ask questions like, is it opaque or transparent? Is it staining? Is it granulating? Is it a good mixer? The only way you can really find out is by actually practicing and experimenting before ever attempting to produce a painting. You must know where you are going or you'll only arrive at your destination after many failed efforts.

PAINT QUALITY AND CONSISTENCY
One of the most important considerations is getting the feeling of the correct ratio of paint to water.

Insufficient water
• Not enough water and too much paint will produce a thick, sticky mix that won't flow. This may be good for dry brush accents in some paintings but if you're looking for a wash then this is not the ratio.

• If you ever feel that you have to push color onto your paper, then most times it will mean that you need to add some water to allow the paint to flow.

Insufficient paint
• On the other hand, if your mix has too much water and not enough paint then that is another problem. The result will be very weak and wishy washy, the water will flow out of control and maybe some undesirable cauliflower edges will result.

Problem effects
Balloons, cauliflower edges, bleed-outs, or whatever you like to call them, are caused by going back into a damp wash with more water than there is on the paper. This problem is often caused by painting with your board flat — always keep your board propped up at the back to allow the wash to flow towards the bottom of the sheet.

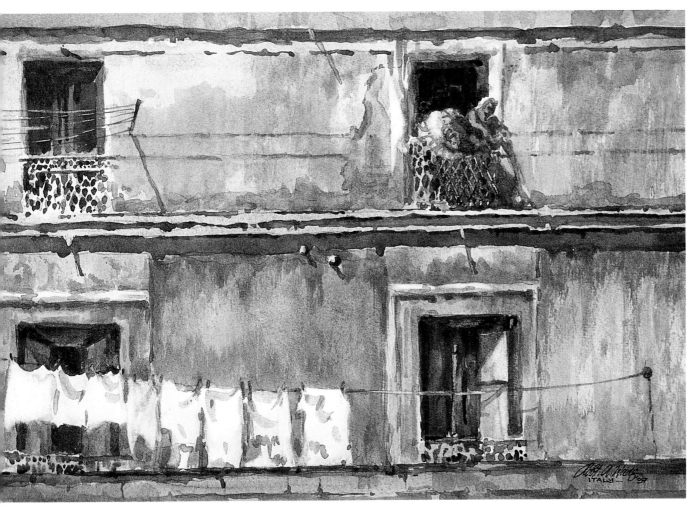

"Hanging Day, Sorrento, Italy", 10 x 19" (25 x 48cm)
The small horizontal bands of cast shadow vary from warm to cool as they run across the sheet. The colors were all dropped in while the shape was wet.

Always mix more wash than you think you'll need. Be generous! A big mix is only worth a few cents, so you're not being too extravagant. To have to stop and mix again when you're in the middle of a wash can cause you many problems. THINK BIG.

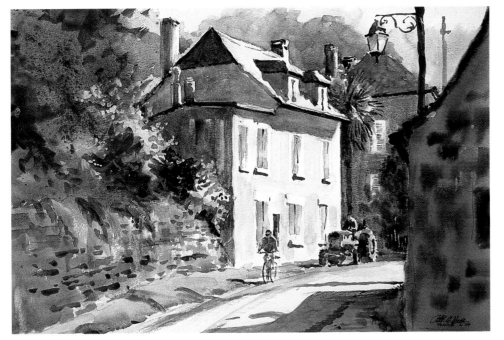

"Morning Near Carsac, Dordogne, France", 14 x 21" (36 x 53cm)
A nice warmth reflected into the cast shadow under the eaves, and the shadow of the lamp-post gives us a link across the roadway.

WET-IN-WET MIXES AND PAPER STAINING CHECK

Try the following sequence of exercises to really get the message.

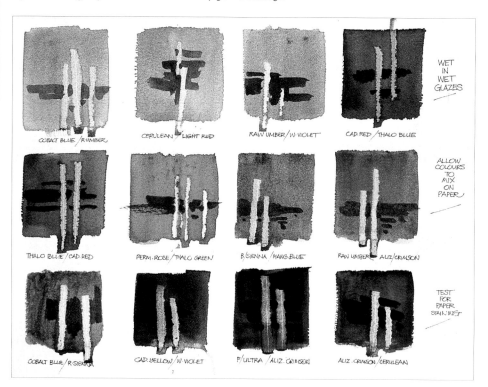

COBALT BLUE / R.UMBER CERULEAN / LIGHT RED RAW UMBER / W.VIOLET CAD.RED / THALO BLUE

WET IN WET GLAZES

THALO BLUE / CAD.RED PERM.ROSE / THALO GREEN B/SIENNA / MANG.BLUE RAW UMBER / ALIZ/CRIMSON

ALLOW COLOURS TO MIX ON PAPER

COBALT BLUE / R.SIENNA CAD.YELLOW / W.VIOLET F/ULTRA / ALIZ.CRIMSON ALIZ.CRIMSON / CERULEAN

TEST FOR PAPER STAINING

1 **Put down the first color then, while it's still wet, go straight back with the second color. Allowing the colors to mix on the paper like this gives a much more vibrant result than mixing the same two colors on the palette.**

2 **Label each exercise as you do it.**

3 **Check out the degree of paper staining by knifing out some lights. This is the kind of knowledge that is vital to your progress.**

4 **Finally, pop a few darks down just for contrast.**

GETTING TO KNOW THE WATER/PIGMENT RATIOS

In the following exercise I have purposely not specified the colors because I want you to see for yourself exactly what happens. Doing it yourself will make it much easier to remember.

1 **Dip your brush into your water jar and transfer two or three brush-loads into your palette's mixing area.**

2 **Flick the brush a couple of times to remove the excess fluid, then dip into your desired pigment and mix it into your wash.**

3 **Repeat that procedure with whatever color you need to obtain the result you're after.**

4 **Test the strength of your mix on a piece of scrap paper to make certain it's right for hue and value and then you're in business.**

Practice this procedure until it's second nature and you will know instinctively if there's not enough or if there's too much of either element in your brush.

It's a good idea to paint these exercises on letter size sheets which you can then insert in a two- or three-ring binder which will become your personal color ready reference.

WARNING!

I've seen so many students do just as I've described, but the first thing they do before putting brush to paper is dip back into the water jar. Immediately the wash breaks down so that both the hue and the value will be wrong. DON'T GO BACK INTO THE WATER!

COLOR MIXING

One of the keys to success in watercolor is understanding how to mix colors. In this section we'll start with a few basic colors, then we'll gradually introduce more colors into our palette as we build our skills.

GLOWING WASHES START HERE

Now that you have the right feeling we can proceed to the next stage. In my own work I guess 98 per cent of the areas in my paintings are COLOR GRAYS. This means that almost every color has another one added to it, leaving only 2 per cent for pure color, and most times there wouldn't even be that much.

I like to put down color that is believable, which can be found everywhere in nature. Some artists paint exaggerated colors and that's fine for them, but I'm telling you my way, the way that pleases me.

Great care must be taken if you intend using pure colors because your work can easily become too pretty and "candy boxy". A couple of students I met in one of my workshops described this as "chicky ducky" — nice phrase!

Here are some suggestions that you should try because they are guaranteed to give you some very pearly, glowing washes (NOTE! These are NOT recipes!)

We will only be using 6 main colors to start with, and we will achieve about 200 color mixes.

You will need: Light Red, Raw Sienna, Burnt Sienna, Raw Umber, Cobalt Blue and French Ultramarine.

Light Red

Raw Sienna

Burnt Sienna

Raw Umber

Cobalt Blue

French Ultramarine

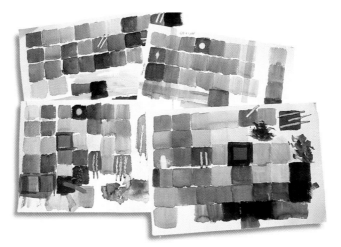

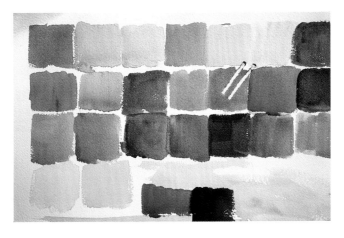

Paint a series of color swatches
On the following pages, you'll find all kinds of mixes, which you can do as swatches. I want you to do numerous sheets of these swatches, mixing grays and greens until you can do them standing on your ear! For a full list of the colors you'll need, turn to page 14.

Keep them for reference
A sheet like this can be put into a three-ring binder, to act as a source of information for you to refer to whenever you are in doubt. Always make those notations on the sheet like C/B + R/S so that you will know that you used Cobalt Blue + Raw Sienna, and so on.

MIXING GRAYS

Definitely do not use Payne's Gray. I previously listed this as an unfriendly color because it dries so much lighter than you think, causing a value problem which necessitates going back into the area afterwards and creating a build-up of pigment. This produces opacity – then MUD.

Try the following exercises and see for yourself how easy it is to control the temperature of your washes.

1 I'd like you to begin with **Cobalt Blue** and **Burnt Sienna**. Mix about equal portions of the two pigments with water and then paint about a 2" square. This mix will give a fairly neutral gray.

2 Now try mixing more blue in the wash, a cooler result is seen.

3 Paint the square, add more Burnt Sienna and you will warm up the wash.

4 Paint this and put another square of it down.

5 Now try adding water and producing lighter values.

6 Finally use the two pigments almost as thick as oil paint. That will give you the darkest dark obtainable from this mix.

This is an exciting exercise for you because you will see dozens of values and hues appearing and you will realise how easy it is to cool or warm, lighten or darken, thin or thicken your washes. All of this is possible with just the two pigments — magic!

From only these two basic pigments — Cobalt Blue and Burnt Sienna — it is possible to paint an entire picture.

7 Continue the experiment by using **Cobalt Blue** and replacing Burnt Sienna with **Light Red**. Be careful to add a little more water because Light Red is a semi opaque pigment.

The grays produced with this combination are quite a lot warmer than our first set. See the difference? By comparison it's now possible to see that the first squares are much cooler than

we'd imagined. What a tool you now possess!

You can control your grays without dipping into every well on the palette, but this is only the start.

8 Repeat the whole process but replace Cobalt Blue, this time using **French Ultramarine**. Make up your chart with mixes of French Ultramarine plus **Burnt Sienna**.

9 When you've done that, substitute Light Red for **Burnt Sienna**. Here's a whole new ball game. Much darker values are now available to you because French Ultramarine is a darker hue than Cobalt Blue.

COLOR TEMPERATURE

WARM
Let's look again at color temperatures. You achieve warmer grays with French Ultramarine (a blue towards the warm side) and Light Red (a red towards the warm side).

COOL
On the other hand, you get a cool color when you mix French Ultramarine (warm) plus Burnt Sienna, which is towards the cool side. Burnt Sienna is also a red towards yellow, so that when you add blue the mix tends towards the green side. This entire journey of discovery is becoming great fun!

MORE COMBINATIONS TO TRY AFTER YOU GET THE IDEA
There are many other combinations that give very pleasant grays but you can discover those yourselves. Anyhow, here are a few more just in case you run out of ideas. Only use these combinations after you have become very comfortable with my original suggestions. Keep it all as simple and uncomplicated as you can.

TRY THESE COMBINATIONS
Phthalo Green plus Alizarin Crimson.

Cerulean Blue plus Cadmium Red (keep this very transparent).

Winsor Violet plus Burnt Sienna.

HINT
No matter what you are mixing it's a good idea to make notations on the sheet as you paint these swatches, for example, writing F/U + B/S lets you know that these colors came from mixing French Ultramarine and Burnt Sienna. It's a good idea to paint these exercises on letter size sheets which you can then insert in a two- or three-ring binder for a ready reference.

MIXING GREENS

If you are painting landscapes it's impossible to avoid green. Most of us would love to leave as much of it out as possible, because it's the artist's horror color.

This is probably because its acid-like vibrations can easily overpower the painting. However, because I paint many golf courses I'm stuck with it!

Here's some of the ways I overcome the problem:

1. I constantly change the greens throughout the painting, rarely going more than a couple of inches across the paper without introducing another mix and changing the color.

2. Somewhere in the painting I always try to introduce a spot of red, the complement of green. It could be a red cap, a red sweater or a red golf bag.

3. I pay attention to color unity. Remember my list of colors? There's only one green included, Phthalo Green and, strangely enough, I seldom use it for mixing greens. Most of my greens are mixed from various blues and yellows. This helps to achieve some unity of color because colors are intermixed throughout the painting. In this way no color intrudes and shrieks out that it does not belong.

DO-IT-YOURSELF EXERCISES

Doing it yourself will make it much easier to remember how to mix the colors of nature.

I want you to do some more exercises in the same way that we investigated the grays.

I won't go through the whole thing again. I will just suggest the colors that I know will work for you.

As before, these colors are the colors of nature and will be found whenever you are painting where trees and vegetation are present.

The colors I'm quoting here are all by Winsor and Newton, so if you are using another manufacturer's colors you may not match exactly the same results as mine because colors vary from maker to maker. That is not to say that one brand is better than anyone else's, I just want you to understand that there will be a difference.

We'll go back to the 2" squares again, but let's begin with Cobalt Blue and Raw Sienna.

EXERCISE 1

1 Starting with equal parts of **Cobalt Blue** and **Raw Sienna** you'll come up with a pleasant neutral green, ideal for foliage or grass.

2 Add more Cobalt Blue and you'll go cooler.

3 Add more Raw Sienna and you'll go warmer.

4 Add more pigment — go darker.

5 Add more water — go lighter. Simple isn't it? It makes life easier when you have a definite "way to go!". To be able to control color gives you a head start.

EXERCISE 2

Here's another exercise. (Don't forget to make that notation C/B + R/S on your sheet).

1 This time, keep the **Cobalt Blue**, take out Raw Sienna and replace it with **Raw Umber**, then repeat the procedure as before.

2 To cool the mix add blue.

3 To warm add Raw Umber.

4 To lighten, add water.

See how easy it is.

You'll find the **Raw Sienna** and **Raw Umber** mix is a little darker than the previous mixes. It would be a good mid value to use as shadow on grass, or foliage that had been mixed with our first combination of Cobalt Blue and Raw Sienna.

EXERCISE 3

1 This time, out with Cobalt Blue and in with **French Ultramarine**, then perform the tasks in the 2" squares as previously listed.

2 After completing these squares, change to **Raw Umber** instead of Raw Sienna and then produce another set of mixes. These are now the darkest greens you can mix from the four combinations and, personally, I use French Ultramarine and Raw Umber a great deal — it's a wonderful combination for dark foliage.

I buy at least three times as much Cobalt Blue as any other color because it's such a wonderful mixer, it's always transparent and never dominates a wash unless you want it to do so.

Mix French Ultramarine and Raw Umber and you will make a wonderful dark foliage color.

The Dukes, Scotland, 29 x 39" (74 x 99cm)
The velvety greens of Scotland are quite different to many of the other courses.

If you can master the grays and greens you will be well down the track to producing paintings that sing and glow.

"The 12th, Yarra Yarra , Melbourne"
As we are on to GREEN it allows me to sneak in another golf course! Notice the constant changes in the foliage colors also the spots of complementary red on the golfers.

MORE COLOR COMBINATIONS FOR GREAT GREENS

Now add more colors to your palette and try these combinations for some great greens:
• Quinacridone Gold plus Cobalt Blue, and Quinacridone Gold plus French Ultramarine, are mixes that will give some super bottle greens.

Aureolin with Cobalt Blue (Aureolin is not too good with French Ultramarine), or Aureolin with a touch of Phthalo Blue will give you the sunniest, most transparent greens, wonderful for the translucent effect of sun through new spring growth

For grass, and brilliant sunshine you could also try Lemon Yellow, New Gamboge, (similar to Aureolin) plus Cobalt Blue. Then Cadmium Yellow plus Cobalt Blue isn't a bad combination, but watch the opacity! Use plenty of water please.

A GREAT STAINING GREEN

Here's an unusual green and this is a real stainer. Phthalo Blue plus Burnt Sienna, makes a great color for pine trees. A blue and a brown gives green? Yes sir!

You see Phthalo Blue is blue towards green, and Burnt Sienna is virtually an orange, which means it contains some yellow, so here comes our green.

Try it out and find out what you think, but watch out for the very powerful Phthalo Blue.

The correct ratio for this mix is about one drop of Phthalo Blue to one bucket of water! WOW!

Should you ever dip into this color by mistake, stop right away and clean up your mixing area because it will completely overpower any other mix. Wash out your brush carefully, then start right over again.

**"The 18th, Commonwealth Golf Club, Melbourne",
14 x 20" (36 x 51cm)**
Here you'll see great variety in the background foliage. The bunkers gave me the opportunity to play with some wonderful reflected light.

**"Huntercombe Golf Club, Oxfordshire",
14 x 20" (36 x 51cm)**
Here are some English greens, which are so different to Australia. The complementary red roof is an important factor here.

WHERE TO GO FROM HERE

After completing these fundamental explorations of your palette's capabilities you will certainly have gained a new respect for your own ability.

Have you noticed that I've kept all mixes to a combination of only two colors per mix? This keeps the maximum transparency and maintains a color dominance in every gray.

You can now try out some three-color mixes if you wish but I can assure you that they won't be better than these. The more colors you put into a wash the more they'll deaden it and the result will be rat's tail gray — yuck!

If you can master the grays and greens, this ability puts you well down the track to producing paintings that sing and glow — keep up the good work! Now you can add a few more colors to your palette.

MIXING PURPLES

Mix combinations of:

French Ultramarine plus Alizarin Crimson.

French Ultramarine plus Permanent Rose.

Cobalt Blue plus Alizarin Crimson.

Cobalt Blue plus Permanent Rose.

Phthalo Blue plus Alizarin Crimson.

Phthalo Blue plus Permanent Rose.

Cerulean Blue plus Alizarin Crimson.

Cerulean Blue plus Permanent Rose.

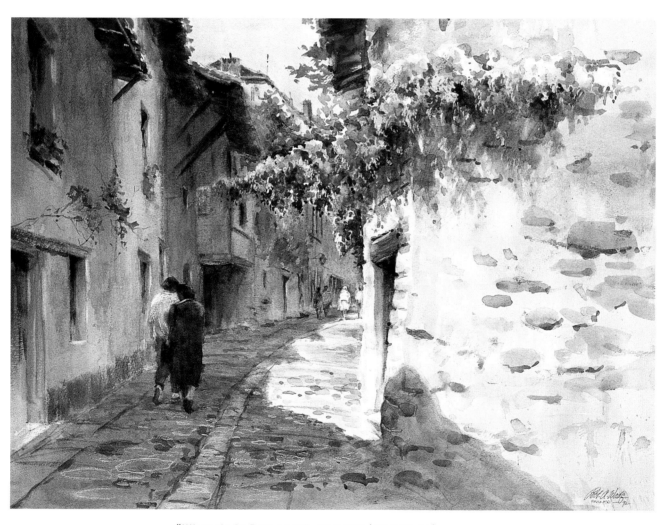

"Wistaria in Perouges", 19 x 29" (48 x 74cm)
This Medieval French village is an artist's dream with its cobble-stoned streets, half-timbered facades, stone walls and more. The touch of mauve and purple lifts the whole painting.

MIXING BROWNS

Mix combinations of:

Burnt Sienna plus Alizarin Crimson.

Burnt Sienna plus Permanent Rose.

Light Red plus Alizarin Crimson.

Light Red plus Permanent Rose.

Then try adding a touch of French Ultramarine and notice the difference that makes to the wash.

MIXING ORANGES

Mix combinations of:

Burnt Sienna plus Aureolin.

Burnt Sienna plus Quinacridone Gold.

Permanent Rose plus Aureolin.

Permanent Rose plus Quinacridone Gold.

Light Red plus Cadmium Yellow.

Light Red plus Lemon Yellow.

MIXING DARKS

This is where I use my Phthalo Green. Try out a mix of Phthalo Green plus Permanent Alizarin plus French Ultramarine. Vary the proportion; try having each one in turn dominant so that you get either a greenish dark, a purplish dark, or a bluish dark. The less water in the mix the darker the result.

These mixes will allow you to hit your darkest value first-up without going back into them — a very desirable effect.

Caution: Remember that they will all stain because of the influence of Phthalo Blue.

**"The Charles Bridge, Prague",
14 x 20" (36 x 51cm)**
Morning light, and the chance to go a little wild with color. Flicks of orange on the statues, warm colors nearest the light and cooler colors away from the light source make the distant buildings of Mala Strana glow. The city of Prague is one of the most magical in all of Europe. I had a wonderful time painting it with my dear friend Jerry Brommer.

One of the most important considerations is getting the feeling of the correct ratio of paint to water.

LET ME PROVE THAT PAINTING WITH A LIMITED PALETTE GIVES A CLEANER RESULT

Here are two good combinations:

1. Cobalt Blue plus Light Red plus Raw Sienna.
2. French Ultramarine plus Permanent Rose plus Aureolin.

These are basically primary color palettes, a red, a yellow and a blue. By intermixing these colors you'll get a wide variety of pleasing transparent mixes.

Using limited colors is a very good discipline because it forces you to make the most of what you have — and isn't that just like life too?

If you think that we are now finished with color, we're not. This is just the beginning, because we now have the basics for more experimenting with the most powerful means that we have for portraying mood and atmosphere — color!

"Port Clyde Church", 11 x 14" (28 x 36cm)
In this quick demo painting color jumps out of every shape.

I like to place color that is believable and that can be found everywhere in nature.

WE'VE PROVED IT — ONLY 6 PIGMENTS MAKE HUNDREDS OF COLORS

By now you've made swatches of about 200 colors and values of mixes coming from
Cobalt Blue,
French Ultramarine,
Light Red,
Burnt Sienna,
Raw Sienna and
Raw Umber.

Only six colors, and by intermixing within the six and mixing
Raw Sienna and Light Red,
Raw Sienna and Burnt Sienna,
Raw Umber and Burnt Sienna,
Raw Umber and Light Red,
another terrific range of warm yellow-oranges will appear. When will it all end?

By now it should be obvious to you that it's not necessary to have 64 different colors squeezed out on the palette. Of course the manufacturers would love you to do just that. The hard fact is that the fewer colors you have to think about as you paint, the faster you can go from well to well, to palette to painting.

Continue to do these simple mixing exercises until you can mix them in your sleep. I assure you that the time spent doing them will be amply rewarded.

"Street in Elba, Italy", 19 x 14" (48 x 36cm)
See the reflected light in the shaded foreground wall? That brilliant sunlit fascia is Aureolin and Permanent Rose . . . WOW!

By now it should be obvious to you that it's not necessary to have 64 different colors squeezed out on the palette.

**"Standley Chasm, Northern Territory",
20 x 14" (51 x 36cm)**
The brilliant colors of "Crocodile Dundee"
country are almost too hot to handle. The
rock face really glows. Note how the small
figures are so important to give scale to the
shapes. Without them we would have no
basis to assess the height.

"Morning Shadows, Prague", 19 x 14" (48 x 36cm)
The fantastic silhouette shapes of the spires are dramatic and
emphasis is placed on them with color. Paynes Gray anybody?

*Too much paint and
not enough water
will produce a
thick, sticky mix
that won't flow.*

"The Green Awning, Bruges", 11 x 14" (28 x 36cm)
That light shape with the accent of lime green lifts the whole picture.

66

**"The Bridge, Chioggia",
14 x 20" (36 x 51cm)**
You may notice many paintings
of Chioggia in this book.
That's because I just love the
place. The orange/purple
complementary contrast works
very well in this watercolor.
I always think that the shape
made by the bridge and the
archway looks a bit like a
prehistoric bird.

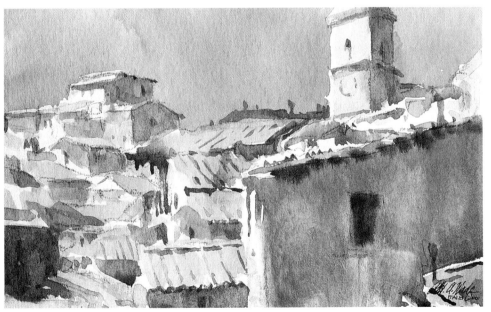

"Elba Skyline, Tuscany", 7 x 9" (18 x 23cm)
A quick little sketch, but the glow in the foreground wall has a good feeling.

5-MINUTE COLOR STUDIES ALLOW YOU TO EXPLORE THE SCENE IN EVERY WAY

Pulpit Rock is one of my favorite places in all the world. This is only ten minutes drive from our house on the coast at Cape Schanck, Australia. I have taken many international artists to paint there with me including Charles Reid, Tom Hill, Harley Brown, James Fletcher Watson and Tony Bennett. Without exception, everybody loved it. This is so wild and unspoiled. There is not much between us and the South Pole and the winds have nothing to stop them, so . . . hang on to your easel!

The five-minute studies shown here portray Pulpit Rock in so many different ways. They are all invented out of my weird old mind, but were really created by the wonderful wet-in-wet glazes I put down first on the sheets. I will go on painting Pulpit Rock forever.

In my own work almost every color has another one added to it.

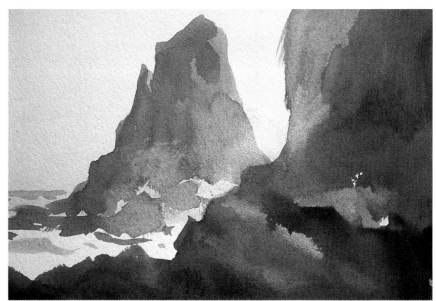

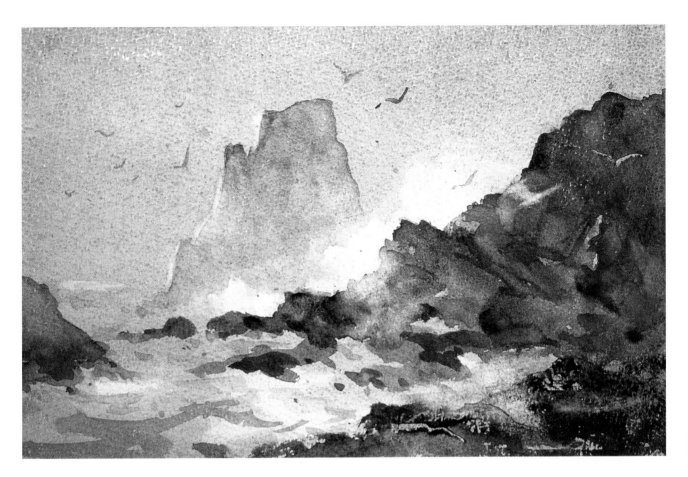

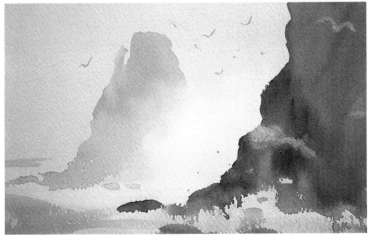

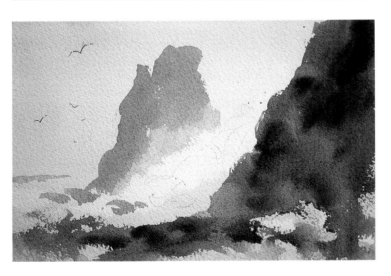

Great care must be taken if you intend using pure colors because your work can easily become too pretty.

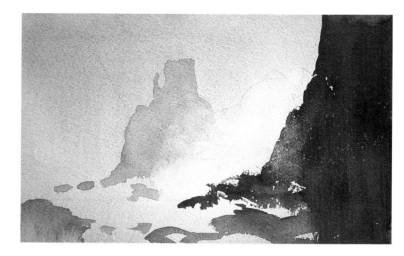

It was the preliminary wet-in-wet glazes that created the feeling in these studies.

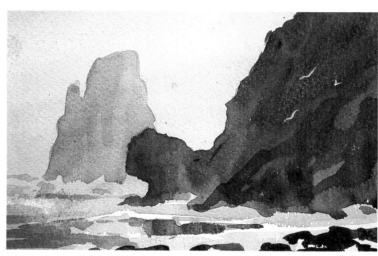

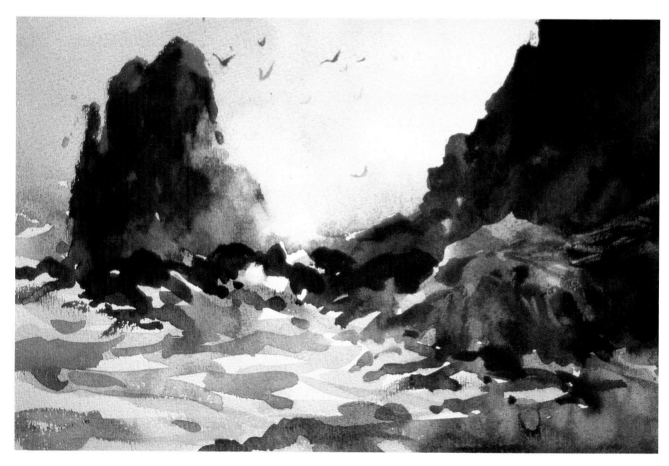

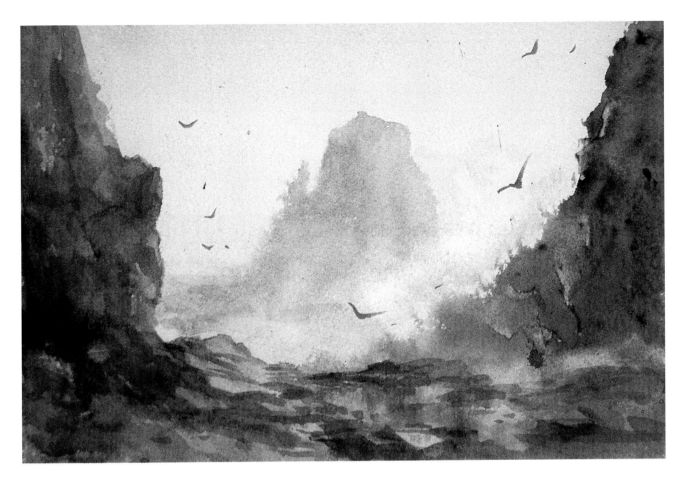

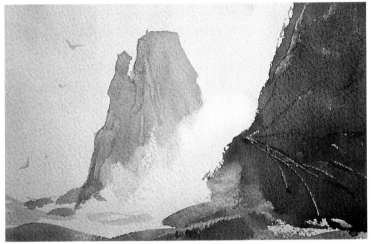

These five-minute
studies portray
Pulpit Rock in so
many different ways
and they were all
invented in my
weird old mind.

GLAZING

The time-honored method of glazing is to apply a transparent wash over a previously painted wash which has been allowed to dry. This transparent layer, or glaze, produces another color because the underpainting affects the final dried result.

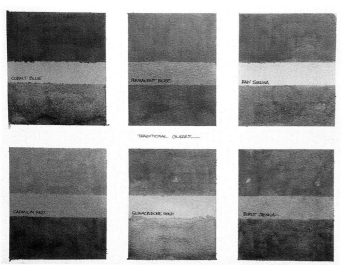

Traditional wet-over-dry glazes
Here you wait for the underpainting to become quite dry before applying the overglaze.

GLAZING

This exercise will really give you the feeling of the entire business of glazing, and you will understand how you can use this technique over selected areas in your work. It's as old as the medium. The early British watercolorists built up most of their values this way by painting layer upon layer.

Try glazing on some scrap paper, maybe the back of failed paintings (soon you won't have any more of these!), or some cheap, student-grade paper. Always make your forays into the unknown a part of studio experimentation. Don't try new techniques "cold turkey" on your outdoor work or on a new work in the studio. It's wise to have "been there, done that", before attempting to include it in a finished painting.

1 So for this new procedure, put down 6 swatches of about 6" square, don't go too small with this exercise.

2 Paint the squares using:

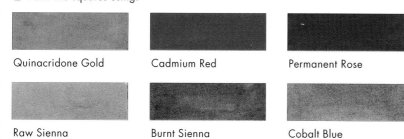

| Quinacridone Gold | Cadmium Red | Permanent Rose |
| Raw Sienna | Burnt Sienna | Cobalt Blue |

3 Then, when they're perfectly dry, use the same 6 colors and paint one on the other covering half of each square.

4 When it's dry turn your board upside down and paint the other halves in different glazes. You'll then see some very interesting results.

Glazing can change an entire painting or can change a small area within a painting. The process is a fairly dangerous procedure in watercolor, but is fine for acrylic or oils. Our problem in watercolor is caused by the possibility of the glaze rewetting the underpainting, so that it lifts as the new wash goes over the top.

Should you decide to put a glaze over your finished painting MAKE ABSOLUTELY CERTAIN THAT THE ENTIRE WORK IS HARD DRY. It's far better to leave it for some weeks if you are at all undecided. Hesitation and tentative brushwork can very quickly sound the death knell for a watercolor. A positive, confident stroke is required to avoid lifting the dry underpainting.

SOMETIMES THE GLAZE CAN PRODUCE A WINNER

For instance, you can change an early morning scene into an early evening scene by using a wash of French Ultramarine with a touch of Alizarin Crimson. If it all works well, that glaze will unify the painting by exerting its influence over every part of the picture.

Of course there is one major worry. The chances of ruining your previous painting are very real; so consider carefully if you really want to take the risk. Weigh up all the possibilities and, if you are in doubt, don't do it. At least leave it for a couple of weeks. While you are considering glazing, your painting is precious to you because you've just spent lots of time producing it. In a couple of weeks it will be only another piece of paper, just history, and if it finishes up being a chuck-out at that time, so what? At least you've had the courage to TRY!

WET-IN-WET GLAZING

One of the fun things to do with our beloved medium is to slosh it around and let it have its head to create effects which are peculiar to watercolor. Here is a way to invent mood and atmosphere and to create feeling that you had not originally envisaged for your subject. Here is Visioneering in a simpler form than I previously explained.

Let me begin by dispelling a popular myth. How many times have you heard people say, "Of course, watercolor is SO difficult, once it's down it can't be altered or corrected". Don't tell anyone, let's preserve the mystique for the uninitiated, but those of us who practice the art know that THERE ARE WAYS TO CHANGE WHAT WE'VE JUST PUT DOWN ON THE PAPER.

Here is the key: as long as an area is wet then it's possible to go back and back, changing it to lighter, darker, brighter, duller, warmer, cooler, or anything you please, providing it stays WET. Once the wash begins to dry that's when another wash will disturb the first layer and produce a dirty result.

Try the following exercise to prove to yourself that you can apply glaze over glaze over glaze.

First wash: Raw Sienna

Second wash: Cobalt Blue

Third wash: Permanent Rose

Fourth wash: Cerulean Blue

Fifth wash: Quinacridone Gold

Sixth wash: Winsor Violet

Seventh wash: Cadmium Red
What? No Mud! The dried sheet needed a minimal amount of work to make it into a painting. The mood was already built in from the seven glazes!

If you decide to put a glaze over your finished painting, make absolutely certain that the entire work is hard dry before you do so.

WET-IN-WET GLAZING

The only way to understand wet-in-wet glazing is to try it yourself.

1 Tape down a piece of watercolor paper about 12 x 10" (31 x 25cm).

2 Paint the entire background with clean water.

3 Remove excess water by blotting with a paper towel. The paper is now damp and is ready to receive the first wash.

4 Ensure that your board is raised up at the back, which encourages the wash to fall towards the bottom of your board. This is the only bit of positive control we have over the medium, so why not take advantage of it!

5 Work right over the entire sheet with an overall wash of **Raw Sienna**. Use a big brush and don't follow the old horizontal stripe method for laying a wash. Just slap it on allowing the brush to follow a sort of herringbone pattern, always applying the brush just above the bead formed by the previous application.

6 After this first application of wash the surface of the paper will be wringing wet, so make sure that it stays that way.

7 Starting at the top left corner, slosh in the next wash of pale **Permanent Rose** making certain to travel over the entire surface. If the new wash begins to run madly down the sheet DO NOT PANIC, just proceed as normally and paint the wash right over the surface until all is covered and you've picked up that problem dribble with a second wash.

8 You will now see a big bead of wash forming at the base of the sheet as the water flows right down. Just soak up that bead with a tissue and again make certain that the board has plenty of angle, at least 45 degrees or more. Look at the wash and you'll see that the colors of the two washes are mixing together but not too evenly — great! Just what we're after!

9 The sheet is saturated so now we go in again with pale **Cobalt Blue** and repeat the glaze. Watch for that big bead again. See what a lovely effect is happening on your paper as the washes are merging with each other! However, this is an exercise to prove a point so let's keep battling on.

10 Back in we go again, this time with pale **Alizarin Crimson**.

11 Follow this up with pale **Raw Sienna** then pale **Winsor Violet**.

That's 6 glazes, but is the mud starting to show? No way, provided that you've kept enough water flowing.

12 OK let's just pop another couple of glazes over. Let's go now to pale **Cadmium Red** and then follow it with our glaze number eight. Will you take a look at that! Eight washes and no mud. The overall wash looks great and there is evidence of the colors visible across the surface.

13 Oops! Quickly now — you forgot about that bead so mop it up fast!

When that sheet is dry, which will take some time, I think that not only will you be surprised at its clarity but you'll also be very pleased with the look of that glaze. You'll be able to imagine it as the base for one of the subjects that you've been wanting to paint for some time, but haven't quite known how to tackle it.

THE BIG TIP NOW IS THIS:

There is no white paper left so your lightest value will be the color of the glazed sheet. Just keep that in mind and then paint your watercolor in your normal way. The result should be very pleasing. It will be less contrasting than usual because there's no white, but it will be more unified, because there's glaze under every part of the picture and the overall effect will be rather mellow and moody. You will see from my examples how just one subject can be the basis for a whole string of different moods generated by the glazes.

4

COLOR & GLAZING

HOW DIFFERENT GLAZES CAN CHANGE MOOD

Chioggia is a wonderful Italian fishing town which is an absolute delight to visit and paint. By using wet-in-wet glazes on the background and plenty of emotion on small 7 x 9" (17 x 23cm) paper, it was possible to portray the scene in many different ways.

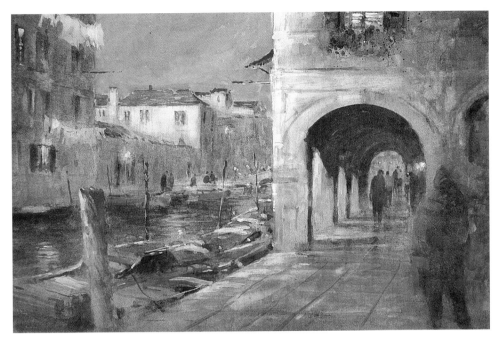

"Misty Chioggia", 12 x 18" (31 x 46cm)
This class demonstration was all about laying glazes over a finished painting. Here it is with TWO glazes over the top, and the second wash started to pick up the underpainting! I would not recommend this to YOU! You will see it was starting to look a bit dirty, but there is still a good deal of feeling in it!

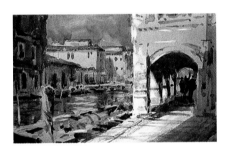
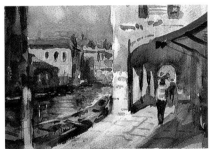
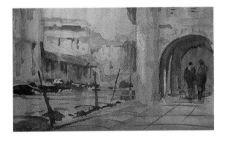

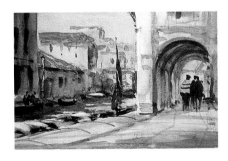

One big tip — only use transparent colors for the glaze or you could be in heaps of trouble.

MORE GLAZING EXERCISES TO TRY

Next, try a number of glazes with different colors now that you have the idea. There's no need to put on as many glazes this time, and if one sheet looks great, stop. Keep that as an example of just how good this method is. How creative and imaginative you can become with it is limitless. J.M.W. Turner, arguably the greatest of them all, often prepared tinted sheets before going out on site. From his variety of colored grounds he chose a background to suit his feelings for the subject.

HERE'S WHAT YOU CAN DO:

Using this newly discovered wet-in-wet glazing, paint about a dozen 12 x 10" (31 x 25cm) pieces of watercolor paper, keeping the glazing washes fairly pale. (The darker you make the glazes the more difficult it becomes to find a subject that suits the tinted sheet.) There will be some very appealing results among them and I'll bet you will suddenly say to yourself, "Oh boy, look at that, wouldn't that make a great painting of the old church at Whereversville that I sketched a few weeks back? I can just see it in my Visioneering mode. I'll silhouette the shape against this lovely glow that I've put down . . ." and on you go. (What fun all of this creating is, not copying the subject slavishly, but inventing means of expressing your reactions to that visual stimulation).

These glazes are really accidental and it's not possible to tell how they will finish up looking, because you can't predict how the washes will react. That's part of the charm and the excitement. "Let's see what happens!" is much more interesting than a predetermined approach you've taken so many times before.

DO-IT-YOURSELF EXERCISE

REACTING TO COLOR

Try this fun exercise which is all about prompting your response to color.

1 Cut several small holes in an old piece of matboard, make them not much more than 3 x 2" (8 x 5cm), some vertical some horizontal.

2 Drop this mat on top of some of your finished watercolor paintings and move it around the pictures. Discover the array of lovely abstract patterns that will emerge as you slide the mat across the surface with many stops on the way.

3 React to the colors and think about how you might use them in one of your next works.

4 Notice how the patterns with big simple shapes will attract you more than the busy little shapes. There is a lesson to be learned here: work in BIG, SIMPLE SHAPES.

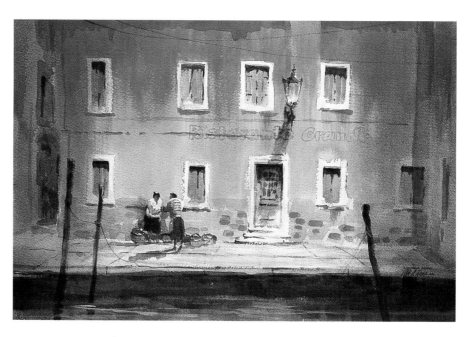

"Chioggia Evening", 14 x 20" (36 x 51cm)
This class demo painting did not work too well at the time. In a subsequent workshop I wanted to demonstrate an overglaze, so I pulled this one out of my folio and applied a glaze of French Ultramarine with a touch of added Alizarin Crimson over the top. The result suggested a night scene, so I added some lights with gouache. In the end I think something good came from the not so good. The motto is, don't give up too soon.

"Antwerp Glow", 11 x 14" (28 x 36cm)
An initial wet-in-wet glaze suggested the way to portray the Belgian port that had once been the home of Peter Paul Rubens. It was a very special visit for me.

"Westminster", 11 x 14" (28 x 36cm)
Another glazed background set the mood for this piece. Its simple silhouette format says as much as if I had spent another three days on the painting.

4

COLOR & GLAZING

77

Know what's important in the scene, then emphasize it with subtle use of edges and shape control. Let me show you how.

FOCUS, EDGES AND SHAPES
SHOW ME HOW THAT WORKS

"The object of Art is to give life a shape."
— Jean Anouilh

Unfortunately, right across the world there seems to be a growing tendency to concentrate on hard edged painting. Paintings produced in this fashion ignore one of the basic fundamentals of art — the lost and found edge.

Because of its very nature, watercolor encourages the merging of edges and shapes, allowing the eye to travel smoothly through the painting and to be taken to wherever the artist has determined to place the centre of interest — the focal point.

The ability to direct the viewer's eye this way and that to the focus area is an extremely important part of the painter's bag of skills.

A good way to think of this idea is to imagine a target superimposed over your subject. The bullseye should be smack dab on the focal point, and all shapes located in the outer circles become more out of focus as they extend further away from that point. To prove that this is the way we see, try the exercise on the following pages.

BOB'S BULLSEYE

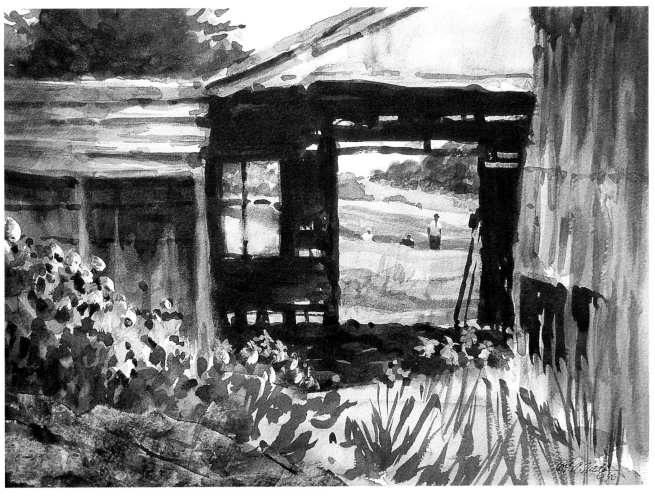

"Old Shed, Ventnor", 11 x 14" (28 x 36cm)
The darkest dark forms a frame around the view into the
distance. See how the eye is drawn by that contrast?

The edges to this
tree are all soft

Because these are
soft edges the
viewer's eye
instinctively knows
the flowers are not
the focal point

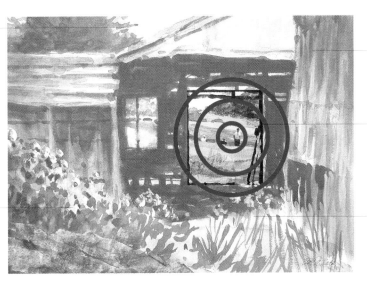

These shapes are
out of focus

The eye is immediately
drawn to the hard edges
and strong contrast of
these shapes

Even the edges of the
foreground have been lost

FOCUS
SHOW ME HOW THAT WORKS

When you complete the "Bob's Bullseye" exercise below you will see that the edges in and near the focal point are the sharpest and hardest and that the contrasts there are the strongest. Keep that image in your mind everywhere you go. "Bob's Bullseye" will help you enormously in your quest for a more painterly approach to your work.

DO-IT-YOURSELF EXERCISE

BOB'S BULLSEYE

Doing this exercise will help you understand the concept of focal point and clarify what you really want to say in your paintings.

1 Ask a friend to stand about 15 to 20 feet away from you, facing you square-on.

2 Stare at the tip of your friend's nose, concentrating hard and not shifting your gaze even a fraction. You will notice that the face is the only area that you can see in sharp focus. Your brain sends the message that everything but the face is a big blur.

3 Next, ask your friend to extend their left arm sideways, but don't shift your gaze from the tip of their nose. That hand is going to be blurry because it's well into the outer circle of the target rings. Your brain is telling you what it is, and what's going on, but your eye won't see it clearly.

4 Ask your friend to extend their right arm and go through the same procedure.

5 Have the person wiggle the fingers of both hands now. Are your eyes really seeing the hands or is your brain passing on that information?

6 This time, shift your gaze from the nose and focus on the left hand. You've moved the target — the bullseye is now on the hand! Getting the idea?

The big hidden problem is this. While making your preliminary drawing for the watercolor, you will constantly shift your target as you move from shape to shape throughout your subject. Each time you concentrate your gaze on a new shape in order to draw it, you have MOVED THE BULLSEYE! When the drawing is done there will be bullseyes all through the sheet.

WHAT TO DO:

You must select the target that is the most important for you.

Once you've decided where that is, then in your mind's eye apply a transparent target over it, and immediately you'll be aware of the areas which are of secondary or tertiary importance.

This is a very good way of discovering what it is you are trying to say in your painting. With that focal point firmly in your mind you can treat the rest of the painting as being a mix of areas where you can blur edges, join shapes and convey an out-of-focus impression to the viewer.

Here the face is the only area that you can see in sharp focus

In this example, the hand and the books are the only things you can see in sharp focus

All shapes located in the outer circles become more out of focus as they extend further away from that point.

EDGES
SHOW ME HOW THAT WORKS

Strategic placement of lost and found edges (soft or hard edges)
is one of the accomplishments that separates the professional
from the amateur.

WHERE DO EDGES COME FROM?

SOFT EDGES
Soft edges come from
wet-in-wet (or, more
precisely, damp-in-
damp). If the paper is
too wet then there will
be very little control over
the marks you make.

HARD EDGES
Hard edges come from
wet on dry.

DRY BRUSH EDGES
Dry brush edges come
from lots of pigment on
the brush and not much
water.

**Wet-in-wet for soft edges and many
joined shapes**

**Wet-on-dry for hard edges and no
joined shapes**

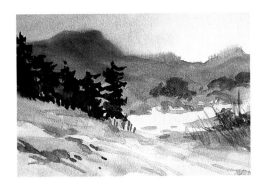

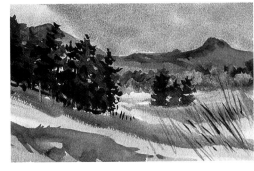

Mixtures of hard and soft edges in these two examples

5

DO-IT-YOURSELF EXERCISE

MAKING SOFT, HARD AND DRY BRUSH EDGES

**Practice on some old paper and produce soft, hard and dry brush edges so that you can make these strokes work for
you whenever you need them. Add this information to your mental grab bag of painter's knowledge.**

1. Dampen an area of your paper
with clear water, watch carefully for
the shine to go, then once that has
happened hit it with a brush full of
wash that's dryer than the paper.
There's no need to be elaborate,
just put down a few lines so that
you can see the effect.

2. Do the same on the dry paper. This
produces the conventional wet-on-dry
and the resulting edges will be hard.

3. Finally, flick out the excess moisture
from your brush so that it's damp,
then make a good strong dark — for
example, French Ultramarine plus
Burnt Sienna — and then drag the
brush across the surface of the paper.
The result will be a lovely, dry brush
stroke with very textured edges.

SHAPES

SHOW ME HOW THAT WORKS

Wherever you have shapes of similar value allow them to join. Allow the colors to flow into each other without worrying about bleeding. The object of this is to allow easy passage from shape to shape, smoothing out the bumps for the eye, so to speak.

Imagine a row of six houses, somewhere in Italy maybe, where each house has a different colored facade.

- If the painter renders each front as a tight little box with hard edges between it and its neighbors, then the painting will have an uncomfortable, broken up feeling for the viewer.
- Instead, think of what happens when those boundaries are allowed to creep and intrude into neighboring shapes. At once there is a unity as the six elements become one shape. We have effectively simplified the painting by smoothing out the transition across the shape. We have turned six small shapes into one large shape.

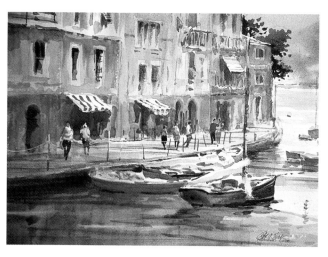

Detail
This section of my painting "Portofino, Italy" shows how I allowed the facades to merge into each other to provide a smooth backdrop for the people and boats.

BIG SHAPES will help make your paintings work.

FOCUS, EDGES AND

REDUCING A COMPLEX SCENE TO SIMPLE SHAPES

1 First the drawing

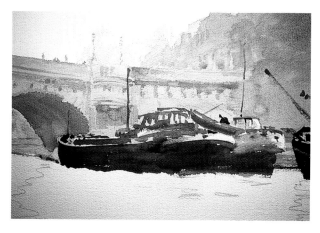

4 Detail
Notice how the top of the bridge runs into the building to make another shape.

SHAPES IN ACTION

Begin your painting with BIG, SOFT EDGED, LIGHT VALUED SHAPES and work through it until finally you are painting SMALL, HARD EDGED, DARK VALUED SHAPES.

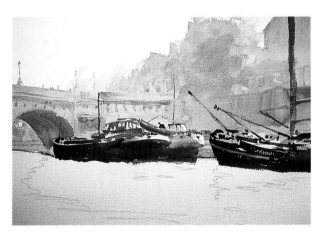

First washes
The bridge, foliage and buildings merge to make one big shape. The dark vessels join to make another big shape.

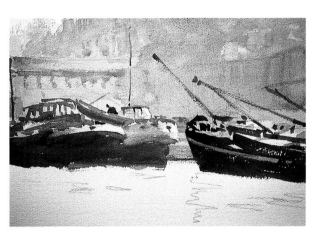

Detail
As you can see, the hulls of the boats on the left are almost indistinguishable from each other.

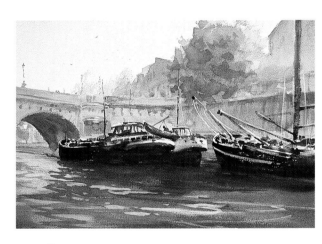

**"Morning on the Seine, Paris",
14 x 20" (36 x 51cm)**
What was a complex scene has been reduced to simple, interconnecting shapes. The boat shapes merge with the water and their own reflections. Examine this painting carefully to identify the hard and soft edges. To emphasize the focal point — the boats on the left — I used the brightest color in this area, the heaviest pigment and the sharpest contrast.

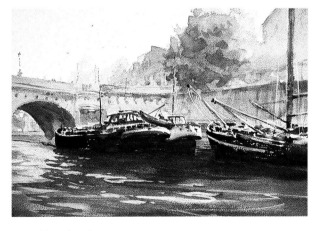

Tonal values map
Viewing the scene in black and white allows you to see how I created a balance of light, mid and dark values.

FOCUS, EDGES AND SHAPES

MAKING SHAPES AND EDGES WORK

Now that you are more aware of edges and shapes, think of this working procedure as a general method.

Begin your painting with BIG, SOFT EDGED, LIGHT VALUED SHAPES and work through it until finally you are painting SMALL, HARD EDGED, DARK VALUED SHAPES.

If you can do that, there's a pretty good chance that your painting will be successful.

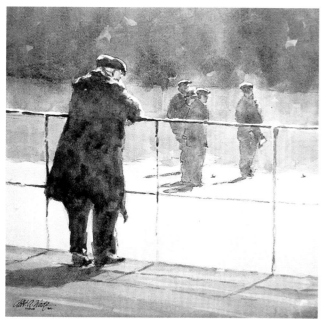

Detail
This detail of my painting "Grand Canal" shows how many different buildings and colors were joined to give unity and to allow the eye to travel smoothly.

"Le Spectateur", 12 x 10" (31 x 25cm)
The players have merged together and have joined into the background shape, while the figure of the spectator has merged with the railings which serves to anchor him. The spectator is also joined to his shadow.

"Mont St. Michel, Normandy", 11 x 14" (28 x 36cm)
I first learned of this place's existence when I was only six years old. My Uncle Bill gave me the first "National Geographic" magazine I had ever seen, and in it was an article about Normandy and the Mont. This vast structure fascinated me and I always remembered it. When I actually got there some 60 years later, it was a very emotional moment for me.

"Morning Sketch, Port Clyde", 8 x 10" (20 x 25cm)
I snuck out very early before my class started and whipped this off before the last of the sea fog disappeared for the day.

"Corner in Camogli, Italy", 14 x 11" (36 x 28cm)

Oh Boy! Too many elements, what a mess! I had to sort it out and get the bullseye working. That orange shape grabs the eye right away. What a lovely old door! Note the warm reflected light under the arch.

"#17, Carcoar, NSW", 11 x 14" (28 x 36cm)

More junk and confusion. It was necessary to get our bullseye working, and sure enough, it centered on that marvelous old fence. The other areas were made secondary otherwise there would have been total confusion, with all elements shouting for the viewer's attention.

"Textures of Turkey", 11 x 14" (28 x 36cm)

Roman tiles, old shutters, and worn window frames. Plenty to play with. I like the cast shadow. Its shape indicates the character of the tiles casting it. Notice the colors of the cast shadow — warm and cool and very transparent.

SELF-ASSESSMENT CRITIQUE

It's time to examine your previous paintings once again.

1 This time I want you to look closely at the focal point in each one. Can you find it?

2 Did you work out where it was before you started or did you hit and hope, just wishing that it would happen?

3 Look at the edges, is the entire painting in focus? Could it be improved by working on, and softening, some of the hard edges that are acting as eye barriers, preventing the eye's passage from shape to shape?

4 Are there any hard edges running out of the sides of the painting? Blur them if there are. (I remember Claude Croney telling me many years ago that one of the last things he did with a painting was to work around the edges with a stiff, damp brush, ensuring that there were no sharp focus lines exiting the painting. That's still good advice!)

5 Can you see some shapes which could have been joined by allowing the edges to merge with a neighbor?

6 Is it possible to work on those areas now in the same way?

By applying this self-critique maybe you can turn a moderately good painting into a very good one. It can't work a miracle for a bad painting but would almost certainly improve any painting that you have done.

To add to your skills, I want to give you some information on the areas of painting that can be developed to help you produce better work. First, we'll discuss light, shadow and aerial perspective, then we'll tackle individual aspects of special subjects.

SUBJECT SKILL BUILDING
SHOW ME WHAT TO DO

"Perceptive observation is seeing with your brain, feeling with your eyes and interpreting with your heart."
— Robert Wade

PAINTING SHADOWS

Shadows give you a wonderful opportunity to go for color and make your painting sing. Please note that shadows are not Payne's Gray!!

Shadows are also invaluable for showing the roundness of form and creating dimension. Learn to use them to their best advantage, allowing them to contrast with the passage of light.

As well, placing a contrasting couple of small darks within the shadow assists in portraying the feeling of transparency.

This is the definitive cast shadow.

Harriet, our 4-year-old granddaughter once visited our home while I was away at a workshop. She said "Nan, where is Bobby?" Nan replied, "He's in Queensland teaching people how to paint."
Harriet burst out laughing, "Nan, you are just tricking me! People don't have to learn to paint, it's so easy."
The innocence of a child! If only we could retain that belief, wouldn't it be wonderful?

"Village near Guilin", 18 x 24" (46 x 61cm)
Very strong foreground shadows place great emphasis
on the light passage across the middle distance.
(This painting is owned by Mr. Tony Bennett.)

THINGS TO REMEMBER	

- Cast shadows are cooler, harder edged and darker at the source. As they move away from the source they are infiltrated by light and become warmer, soft edged and paler.
- Avoid getting into detail inside a shadow shape. Keep any detail out in the areas of light. A ploy that was used by the old-timers was to throw a cast shadow right across the foreground. This still works today! The dark shape has the effect of pushing the background into the distance, helping to achieve the feeling of depth and the third dimension.

Cast shadows are cooler, harder edged and darker at the source. As they move away from the source they are infiltrated by light and become warmer, soft edged and paler.

PAINTING REFLECTED LIGHT
SHOW ME HOW THAT WORKS

Reflected light should be discussed at the same time as shadows because it certainly affects the shadow areas. The camera won't show this light bounce effect, so you will have to invent it if you're using photographic reference.

Observing all the qualities of light is another valid reason for making regular, on-site painting excursions. Get into the Great Outdoors and see where it all happens.

Observe the shadows, see the influence of reflected light and generally be aware of life and nature, and remember that photographs are devoid of this reality and emotion.

I guess that the term "light bounce" describes it better. It refers to the influence of light outside the shadows reflecting back into the shadows and shadowed areas. The color of the light shape bounces back into the darks and thus exerts its presence in very positive fashion. Look at the examples to understand just how important it is to introduce color into areas that would otherwise be rather dead. Sargent never missed an opportunity to slash in a bright orange stroke to make his shadows sing.

HINT
Art is a solitary business and after long hours in the studio without conversation, apart from the annoying phone call which always comes when you've arrived at a critical point in your painting, it's vital to restore balance.

Take time for a walk in the woods or down the street to look at the outside light, to feel the breeze, see the trees and the flowers. Hum a happy song, chat to a neighbor and then all's well and you can return to the fray, refreshed and ready for battle. If your eyes were in painters' mode on your walk did you notice the influence of reflected light in the shadows? Oh yes. It WAS there, so you better go out again if you missed it.

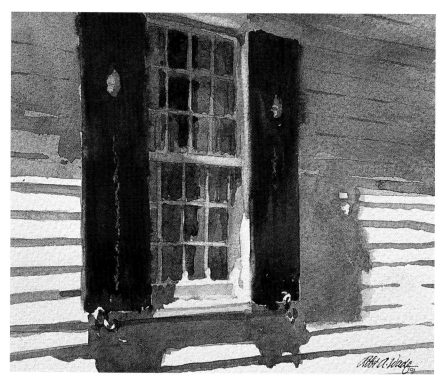

"Thistledown Farm", 8 x 10" (20 x 25cm)
An under-wash of Permanent Rose and Raw Sienna gave a warm glow to the cast shadow. Can you see any dead colorless shadows? No way.

'Light bounce' refers to the influence of light outside the shadows reflecting back into the shadows and shadowed areas.

The color of the light shape bounces back into the darks and thus exerts its presence in very positive fashion.

How the scene looked at first squint

Can you see the light, mid and dark tones?

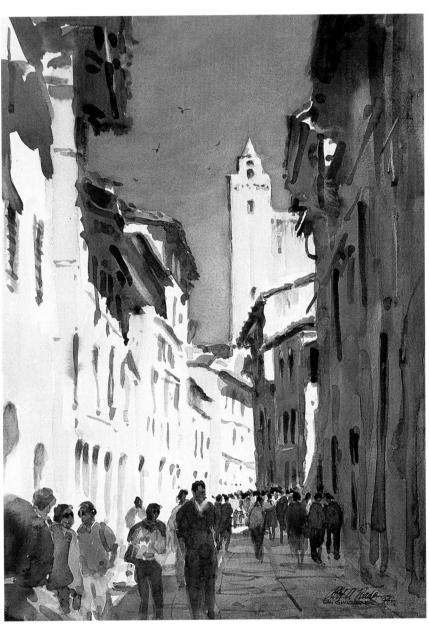

"San Gimignano Street, Italy", 19 x 14" (48 x 36cm)
Strong light bounce into the wall at the right has a beautiful warm glow. I used a buff tinted paper here instead of an underwash.

SUBJECT SKILL
BUILDING

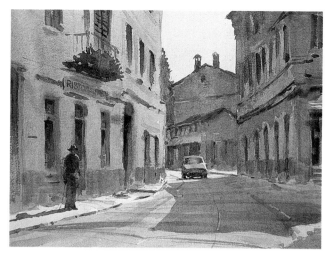

"Heavy Traffic! Belano, Italy", 11 x 14" (28 x 36cm)
An overall glow warms all the shadows, and can't you just smell the cappuccino?

"New Delhi Shadows", 11 x 14" (28 x 36cm)
Long, pale mauve cast shadows, with very little detail. Squint hard to see the good, abstract pattern. It's important to remember that linear perspective also applies to cast shadows.

**"Quadrangle Shadows, Winchester College, England",
14 x 21" (36 x 53cm)**
I really enjoyed visioneering the three fellows half in, half out, of light. All shadow areas have a glow from reflected light.

"The Hangout, Boccadasse, Italy", 12 x 9" (31 x 23cm)
The cast shadows form great patterns on that brilliant wall, enhancing the three-dimensional effect.

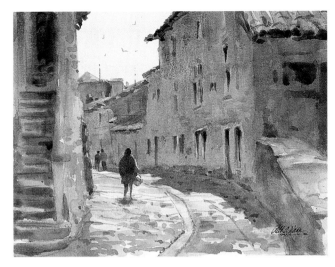

"Pérouges, France", 11 x 14" (28 x 36cm)
What a glow on that wall in shadow! Just cover it with your hand to
see the influence it has on the mood of this little watercolor.

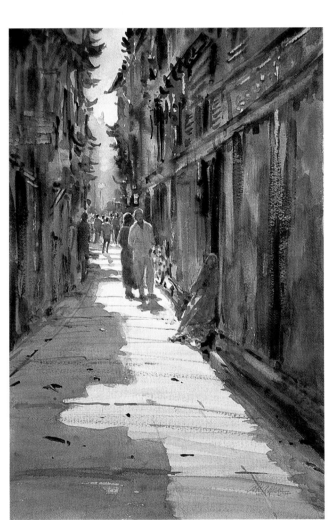

**"Winter Light, Kathmandu, Nepal",
19 x 14" (48 x 36cm)**
Against the light, and the rim lighting of the figures is very
attractive. The small dark accents within the cast shadow give
it transparency.

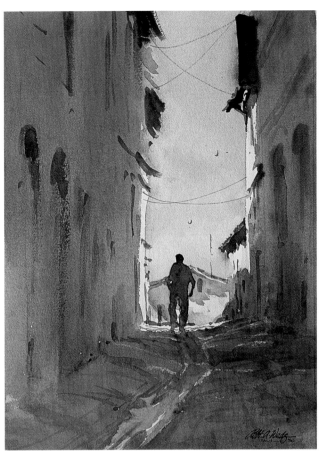

"Side Street, San Gimignano", 14 x 11" (36 x 28cm)
Cover the glow of reflected light on the wall at the left. Isn't that
different? That warm glow lifts the feeling and the spirits.

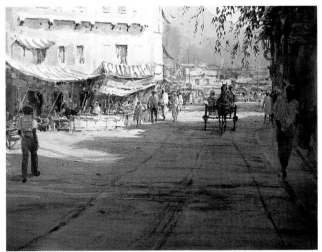

"Winter Sunlight, Jaipur, India", 18 x 24" (46 x 61cm)
About three-quarters of the scene is in shadow but that makes the
light shape work. There are many subtle value changes within the
foreground shadows.

PAINTING LINEAR PERSPECTIVE
SHOW ME HOW THAT WORKS

Our paper only has width and height. However, by employing aerial perspective and linear perspective we can trick people into believing that there really is depth in our work.

Linear perspective is most important to understand and observe. Those of you who paint architectural subjects know how critical it is to ensure that the converging lines go the correct way, otherwise buildings look as if they are falling over, or they lean crookedly to one side. Basic perspective is all you need to know and if you take time to do the exercises on this page you'll quickly get the idea.

DO-IT-YOURSELF EXERCISE

AN EASY WAY TO UNDERSTAND LINEAR PERSPECTIVE

Doing it yourself will make linear perspective easier to remember.

1 All lines converge to a vanishing point that falls on the horizon.

2 To locate the horizon (your eye level), place a pencil at right angles between your eyes, extend your arm so that the pencil is always at right angles to your body then it will point directly at the horizon.

3 Just imagine the horizon line running from that point through your subjects and then think:

4 ALL LINES BELOW EYE LEVEL WILL CONVERGE UP TO THE HORIZON.

5 ALL LINES ABOVE EYE LEVEL WILL CONVERGE DOWN TO THE HORIZON.

That should dispense with any confusion. No more buildings that point up into the clouds!

DO-IT-YOURSELF EXERCISE

CHECKING YOUR DRAWING

This method makes drawing buildings, barns, street scenes, churches, or whatever, much easier to tackle because it's possible to keep on checking, and it's so fast and easy.

1 Extend your right arm, full stretch, holding a pencil at right angles to your arm.

2 Close your left eye, then rotate the pencil until it appears to be resting on the line in question.

3 The arm then lowers to the paper, retaining the angle of the pencil and this angle gives you the correct line.

4 If you find your line is substantially out, change it.

Just one thing though. Make certain that the pencil remains at right angles to the arm and do not bend the elbow.

Have a practice run checking roof lines, fence lines, ground lines, and so on. You don't need to spend hours laboriously reading any of the dozens of boring books on architectural perspective. This idea works for the artist in a very practical way.

PAINTING AERIAL PERSPECTIVE
SHOW ME HOW THAT WORKS

We attempt to give the impression of depth by the use of aerial perspective. This is how it works: Because of dust and moisture particles in the air, a veil of atmosphere makes distant objects appear paler and grayer. That's a truth employed by painters since time began.

AERIAL PERSPECTIVE:
Pale, cool colors and soft edges recede.
Dark, warm, hard edged colors advance.

Using this truth we can paint a convincing watercolor in which the viewer gets the feeling of being able to walk right into the painting. It's something that I want to get into my work — this feeling that air surrounds all the shapes and puts space between the various elements within the picture plane.

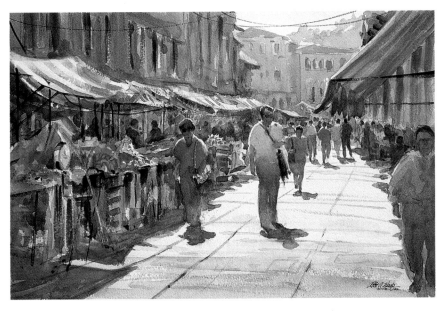

"Rio Terra San Leonardo, Venice", 14 x 21" (36 x 53cm)
The buildings in the distance are cool and pale, with very little detail, and they give us the impression of being further away.

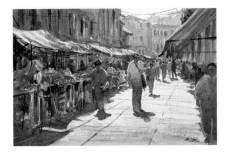

Linear perspective
Here converging lines running to the horizon give the feeling of distance. Notice the size of the various figures too.

Aerial perspective
The buildings close up are more distinct, the distant ones softer and grayer.

AN EASY WAY TO UNDERSTAND AERIAL PERSPECTIVE

Here is a simple procedure to help you clarify the effect that aerial perspective has on the landscape.

Take a piece of lightweight cardboard, (an old cereal packet will do), cut a portion about 8" (20cm) square to make a viewer. Near the center, with your pencil, poke two holes about 1½" (4cm) apart. Work the pencil in and out a few times to get nice round apertures. Look at the landscape and select two light value shapes, one close to you and one in the distance. Manoeuvre the viewer so that both light shapes are filling the holes, (that is, the nearby shape is visible in one hole and the distant shape is visible in the other). Compare the two for color and you will see that the distant shape is grayer and cooler than the shape close to you. Now do the same with two dark shapes. The shape closer to you will appear darker and warmer that the distant shape. Isn't it simple? That is the whole basis of Aerial Perspective, which allows us to give the impression of depth — the third dimension.

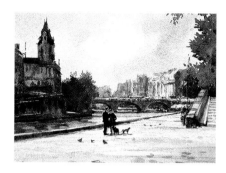

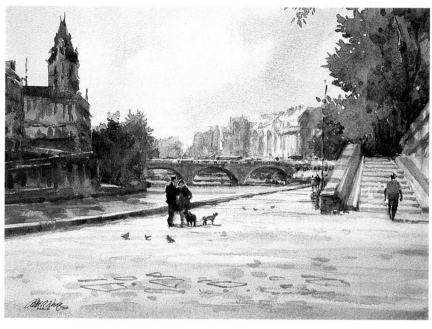

"Sunday Morning, Paris", 11 x 14" (28 x 36cm)
The distant buildings become cooler and paler, detail becomes much less, and so the depth is achieved.

"Russell Burn, Western Highlands, Scotland", 14 x 21" (36 x 53cm)
The distant mountain is pale and diffused, all detail is kept to the foreground, the feeling is one of great distance. This is aerial perspective at work.

"Afternoon,
Cortona, Italy",
13 x 10" (33 x 25cm)
A strong shadow pattern
and good contrasts with
the light shapes. The soft
pale area gives the illusion
of distance.

DO-IT-YOURSELF EXERCISE

1 Imagine yourself standing on my
 "observation point" when I painted
 the pictures on these two pages.

2 Where is your eye level in relation to
 the objects in each of these paintings?

3 Which lines converge down?

4 Which lines converge up?

For instance, in the painting above you can
quickly see that the ridge of the roof on the
horizon line is at the same height from which
you are looking.

Note also that the veil of dust and
moisture particles in the air makes the distant
objects so pale they are almost invisible.

PAINTING SKIES
SHOW ME HOW THAT WORKS

The landscape painter must be able to paint believable skies. Constable said, "Never neglect the sky. It sets the mood for the entire landscape". Who would argue with him? Not me!

The examples shown here will give you the idea of how to practice skies. A quarter-sheet sheet divided into four is ideal for this project.

You don't have to look far for a subject, there's a sky to study right outside your door!

PAINTING SKY STUDIES

In the following exercise I have purposely not given the colors because I want you to see for yourself exactly what happens. Doing it yourself will make it part of your normal way of working.

Paint heaps of these small studies, not only are they good for your sky knowledge, but they are good practice for your general painting.

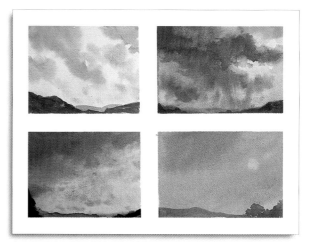

WHAT TO DO

Observe the sky closely and become conversant with all sorts of sky moods, from glowering, overcast skies to lilting, airy skies filled with scudding clouds.

Here are some tips:

1 Make your sky studies just that. In your design, allocate at least three-quarters of the space to the sky. Drop in a very simple foreground as a means of anchoring the skyscape but eliminate detail in that foreground shape.

2 Just as in all perspective, make the clouds overhead (which are nearest to you) larger, and the distant clouds (furthest from you), smaller. This will help to make your sky recede and give dimension to it.

3 Overhead, the sky is bluest or darkest, then it lightens gradually as it recedes to the horizon. This effect can be exaggerated a little to make your painting more effective.

4 If you have a very busy sky in your painting, keep the landscape simple. Conversely, if the landscape is busy, keep the sky simple.

5 Observe the colors of the sky and be certain to include some of that color in your foreground colors. In a seascape you must understand that it's not possible to paint the water bright blue if the sky is overcast and dark gray. The color of the sky will always influence the color of the water.

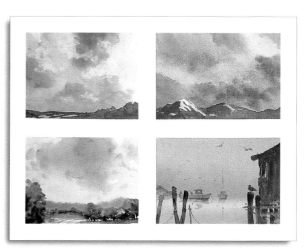

6

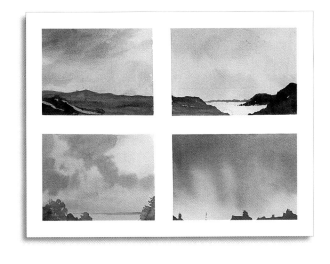

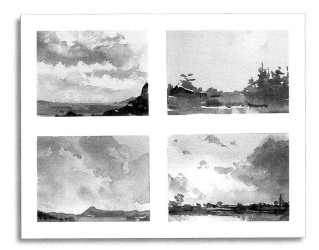

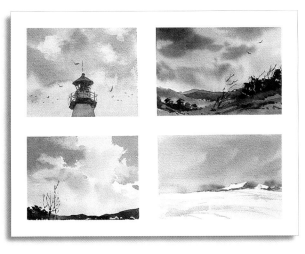

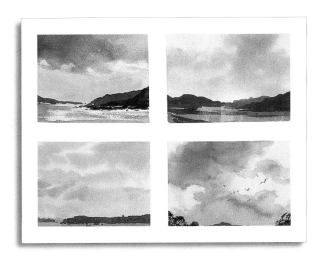

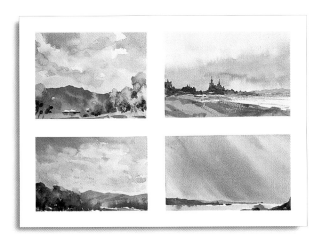

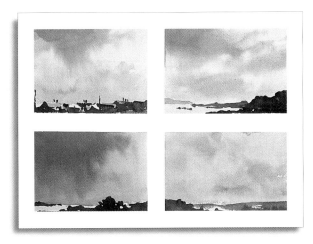

Sky studies: A quarter-sheet divided into four sections will be fine for these exercises.

PAINTING WATER
SHOW ME HOW THAT WORKS

I think that the main advice I can offer is don't worry too much about painting water, for if you do, then there'll be too much niggling and stippling.

Again, observation is the key. If you look at the action, you'll find your brushstrokes closely mimicking the movements and rhythms of the water you're painting. Let it happen! Choppy water, rough water, still water, moving water.

Watercolor is an ideal medium for painting water if it's allowed to get on with the job.

WHAT TO DO

1 Paint the value of the lightest area over the whole shape as a beginning.

2 As water comes closer to the foreground it reflects the sky overhead, so drop more pigment into the water.

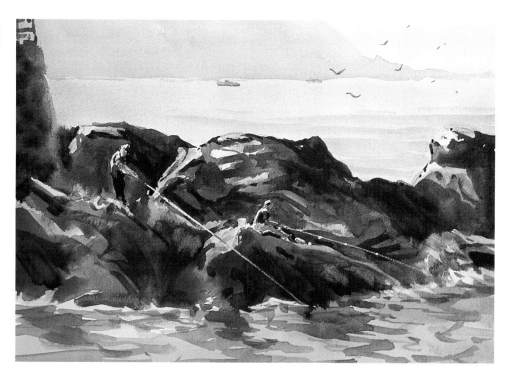

"Old Rockers, Camogli, Italy", 11 x 14" (28 x 36cm)
Quiet water behind the breakwater is hardly more than a graded wash. In front, there is a little chop, so the suggestion of the water licking at the edge of the rocks and the short brushstrokes give the feeling of movement.

6

SUBJECT SKILL
BUILDING

If you look, you'll find your brushstrokes closely mimicking the movements and rhythms of the water you're painting.

"Washing Day, Guilin", 21 x 14" (53 x 36cm)
The lady is the focal point. The concentric circles of the ripples lead us straight to our focal point. Once more I stress the fact that the lightest value of the water was painted first . . . look at it closely. The very soft, circular swirls were painted when the first wash was still wet.

"Maine Morning", 11 x 14" (28 x 36cm)
The paper was prepared with a strong wash of Cobalt Blue and Light Red. The focal point of the two overlapping boats is powerful and needs to have the rest of the painting reasonably quiet. The wash did the trick. The lights were added with gouache. The figures were invented.

"The Grand Canal", 14 x 21" (36 x 53cm)
Here is some pretty smooth water but the currents are visible and make a very good pattern.
 The initial sky wash was continued down right over the water area to tie the two together.

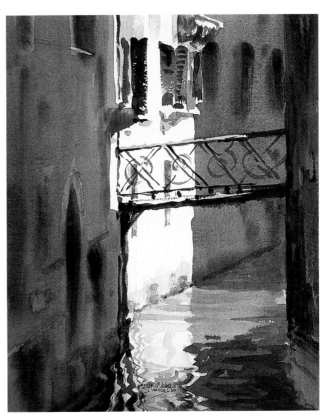

"Sunlit Corner, Venice", 14 x 12" (36 x 31cm)
Simple shapes but brilliant LIGHT! The ripples make a lovely pattern and notice how the shadow on the water maintains the water's horizontal plane.

PAINTING REFLECTIONS
SHOW ME HOW THAT WORKS

It is difficult to come up with instruction for reflections
when we're not on-site together and the reflections are not
right before our eyes. OK, here are some observations.

"Green Doors, Venice", 12 x 12" (31 x 31cm)
The reflections were lifted out with a thirsty brush while the water
wash was still wet. Notice that the light reflections are right
opposite the shapes that are being reflected.

6

SUBJECT SKILL
BUILDING

*Paint long, vertical reflections at the same time
you do the water. When that wash is dry add
the detail of local reflections over the top.*

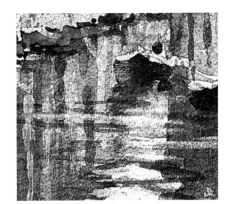

"Canal Reflections", 8 x 12" (20 x 31cm)
A wet-in-wet glaze of Manganese Blue and Permanent Rose went over the entire sheet.
The Manganese Blue can readily be seen as it always settles into the grain of the paper.
The vertical reflections were painted into the horizontal reflections while they were still wet.

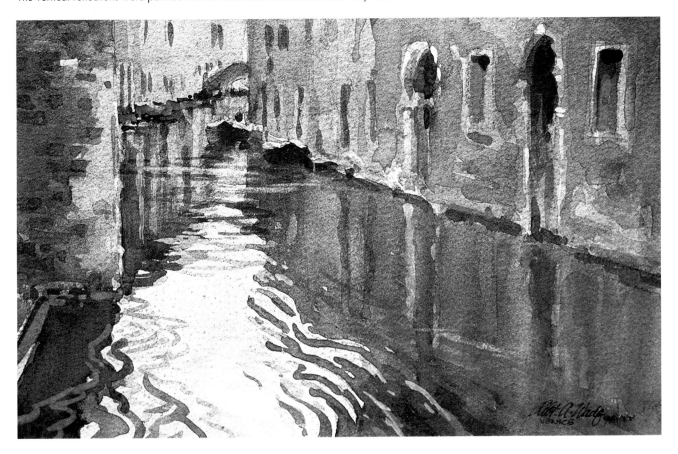

WHAT TO DO

1 Always paint the object before you paint its reflection. Then it's easier to locate the extremities so that the object and the reflection line up and look like they belong. Soften the line that divides the two, so that one shape emerges.

2 Paint the long vertical reflections when painting the water. Wet-in-wet will keep that nice soft look of still water. When that area is dry the local reflections can be painted over the top of the wash.

3 Observation is once again the key to the whole business. Look, look, look. Ask yourself, "Why is it so?". Keep the reflections as simple as possible to give the viewer a chance to use some imagination.

4 A ploy that helps to maintain the horizontal plane of the water is to lift out a light streak or two. Use a damp bristle brush, paint the streak on the surface with the brush, lift out with a rag or tissue. No more than three streaks please.

5 Light shapes reflect darker than they actually are. Dark shapes have lighter reflections.

6

SUBJECT SKILL BUILDING

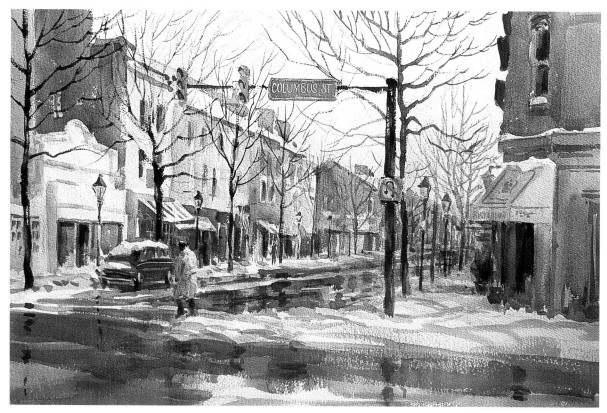

**"Columbus Street, Alexandria, Virginia",
14 x 21" (36 x 53cm)**
Reflections between the snowdrifts establish the plane of the roads.
I remember that 15" of snow fell on the Washington D.C. area
overnight and all the airports were shut down for three days.
Somehow or other all of my students still turned up on time!

*A ploy that helps to maintain
the horizontal plane of the
water is to lift out a light
streak or two. Use a damp
bristle brush, paint the streak on
the surface with the brush, lift
out with a rag or tissue. No
more than three streaks please.*

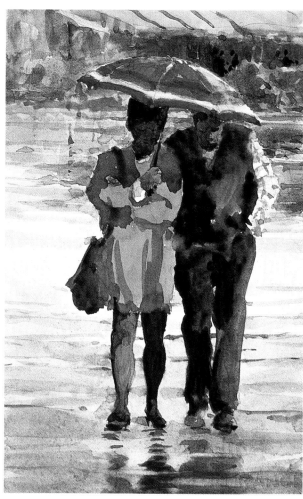

"A Wet Walk, Portofino", 9 x 7" (23 x 18cm)
A simple little study, but the horizontal streaks breaking the
vertical reflections are very important.

"Gliding Along, Venice", 14 x 21" (36 x 53cm)
A reflection painting. Final touches for the reflections of the gondolier were done with opaque white and a touch of Raw Sienna.

Here's the painting again, this time smaller so you can truly appreciate the effect of the reflections in the water.

PAINTING BOATS
SHOW ME HOW THAT WORKS

Spend time observing the SHAPES of boats, their details, and the way they sit in the water.

"The Monhegan Boat",
11 x 14" (28 x 36cm)
When drawing boats it is important to get the feeling of the form. Notice the roundness of the vessel and how the rust streaks help to maintain that curve?

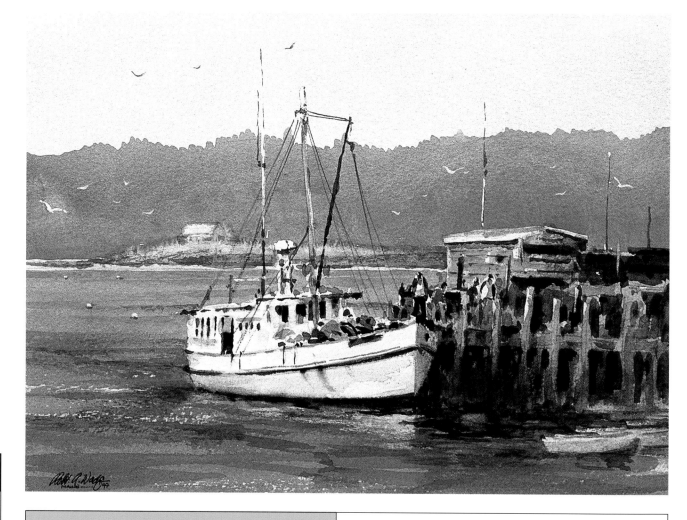

WHAT TO DO

There is no recipe for boats I'm afraid. Boats are like people, and they are all different. I can only say: Observe!

1 Look hard with your artist's eye and draw that SHAPE just as you draw any other shape. A boat is no more difficult to draw than a shed or a tree or anything else.

2 LOOK AND THINK. Compare angles and intersections, measure one part against the other. Again, this is how we draw any object or shape. Draw lots of boats so that you become conversant with the feeling of them.

3 Perhaps one of the aspects that you must master is to paint the boat so it looks as if it is sitting IN the water. Boats have hulls and keels, they don't stop at the waterline.

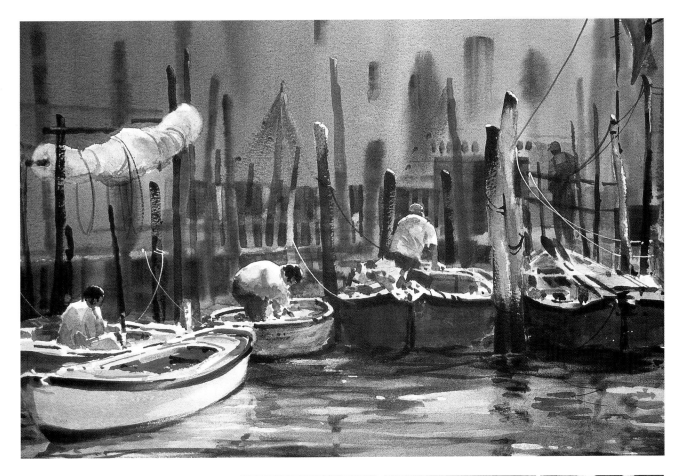

"The Red Flag",
19 x 29" (48 x 74cm)
The form of the small boats has been noted and maintained. The artist's eye is trained in critical observation as we constantly ask ourselves, "Why is it so?" Squint hard and see the passage of light across the boats.

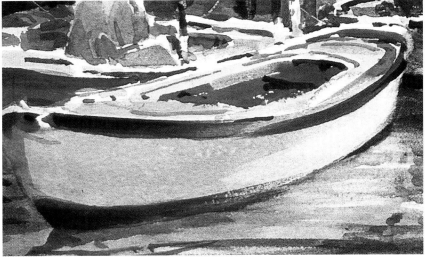

Detail
The shape of the white boat's form is indicated by its shadow and reflection.

LOOK AND THINK. Compare angles and intersections, measure one part against the other. This is how we draw any object or shape.

**"The Ferry at Walberswick, UK",
12 x 18" (31 x 46cm)**
Marinas are a terrible mess although they are such
great places to find good subjects. The answer here
was to simplify and eliminate. Amongst all this rubble
there is one sail, lots of masts and three shapes which
are recognisable as boats. The brain converts all the
other pieces into an image of a busy boatyard . . .
another big con trick!

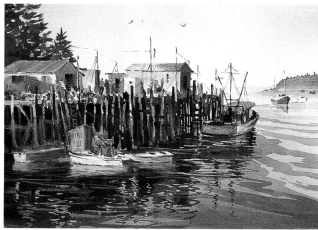

"Morning, Port Clyde", 14 x 21" (36 x 53cm)
The boats are not drawn in fussy detail but they are accurate
enough to be acceptable to any seaman.

"Fishermen's Cove, Amalfi Italy", 21 x 19" (53 x 58cm)
What a fairy tale subject this is! I felt that I had stumbled into some
previously unknown world and was intruding into a private haven
from the outside rat race. The little boats had to be accurate, and
the way they were scattered in such random fashion adds to the
charm of the piece.

"At Rest, Manningtree", 14 x 21" (36 x 53cm)
How interesting these boats look as they nestle down into the marsh
grasses which lock them in like jigsaw pieces.

"Ripples at Looe",
12 x 15" (31 x 38cm)
The color of the water is NOT blue, but doesn't it look more interesting this way, and doesn't it complement the warm color of the boats? The ripples were painted on when the lighter value was dry.

"Silverpoint, Cowes",
6 x 8" (15 x 20cm)
A fast little sketch, just what watercolor is about! Is it a boat or is it a banana? Who cares? It provides a nice bit of color on the beach!

PAINTING TREES AND FOLIAGE
SHOW ME HOW THAT WORKS

- Always show the textures on the edges of the shapes.

- Show the leaves on the outside of the foliage, not within the shape. This gives an instant indication of the type of tree if you want to show that, or it indicates right away that this is simply a tree.

- Looking at the very early British watercolors, you will notice there was a lot of calligraphy added to foliage shapes with many leaves indicated inside the shapes. These were painted at the time when sketches were made to represent and report actual scenes, before the camera came into being. Gradually, artists moved further away from reporting facts and more to impressionism as watercolor developed. I'm sorry to say that today many artists seem to be moving backwards and are aping photography once again.

- Building up a library of sketchbook studies and renderings of trees and foliage will always stand you in good stead, providing a source of reference for future paintings.

- Remember, as for all subjects, paint how it feels not how it looks. Try hard to get the FEELING of the foliage not the detail.

Trees are kind subjects for painters. If you set out to paint a pine tree and it finishes up looking like an oak, it probably won't make much difference to your painting. On the other hand, if you set out to paint a horse and it turns out looking like a camel, you're in heaps of trouble!

Imagine we're out on site and there's a stand of some 15 to 20 assorted trees. The temptation is to paint them individually, almost in botanical style, each one recognisable as a ponderosa pine, redwood, oak, or whatever. We're not in that business. Those trees are SHAPES and they unite to make another element in our painting.

Squint and squint until you realize that they all join together to make one large shape which is identifiable as trees and foliage only because of the trunks and the indication of texture of the foliage on the edge of the shape. Now paint them just like that, allowing them to integrate comfortably into their surroundings.

"Oak Canyon, Sedona Arizona", 14 x 21" (36 x 53cm)
All the tree shapes mass together to form the big shape that I keep talking about. This was painted on buff tinted Bockingford which you can see showing through in the sky and sandy areas. Let your paper do some of the work.

Squint and squint until you realize that trees all join together to make one large shape.

This monotone view allows you see the tonal plan and abstract shapes.

Remember, things closer to you are darker and sharper. The same goes for foliage.

Go back to the section on mixing greens for help when confronted with a mass of foliage.

Lots of good textural foliage marks, including dry brush flicks. I could not resist popping in the solitary figure.

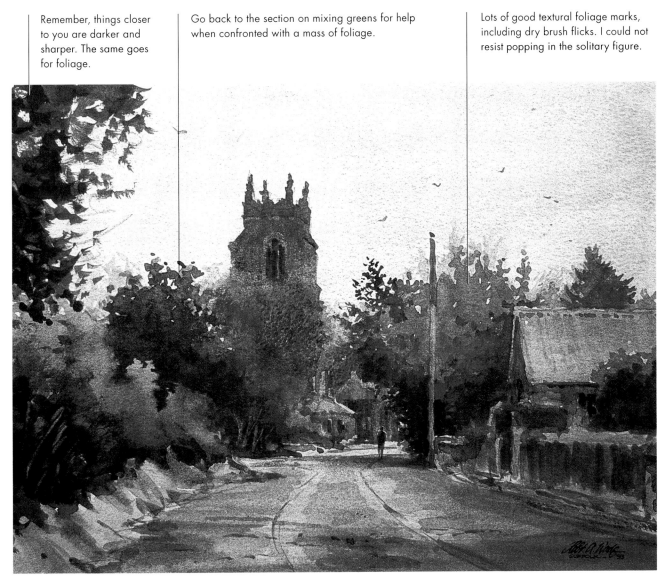

"Stoke by Neyland, Suffolk", 11 x 14" (28 x 36cm)
A typical English subject with the village church dominating the skyline.

6

1 Look closely at different types of trees and notice how each one has some sort of individuality.

2 Note the way the foliage is distributed and the direction in which the branches grow. For example, the branches of pines slope downwards because Mother Nature is providing a slide to clear build ups of snow before branches break under the weight.

3 By noticing this and other features you will develop a storehouse of knowledge that will enable you to give a believable impression of the tree. Once again, "Why is it so?" could be your catch phrase.

You see, there are not even any branches. The illusion of trees works.

Enjoy these subtle, grayed greens. Again, revise mixing greens in section 4.

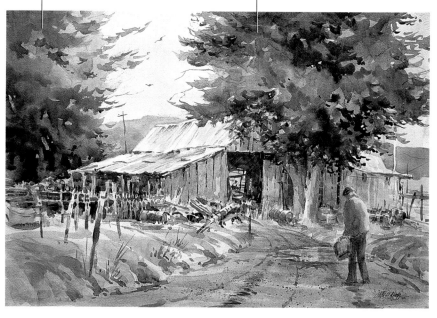

Barn at Millthorpe, New South Wales, Australia, 19 x 29" (48 x 74cm)
This class demonstration concentrated on textures and the two big tree shapes show clearly how leaves are suggested mainly on the edge.

"Winter in Sofala, New South Wales, Australia", 14 x 21" (36 x 53cm)
Pale cast shadow informs us that the sun is fairly weak so it must be coming up to winter. There's still plenty of foliage present though. Look at the edges for the textures.

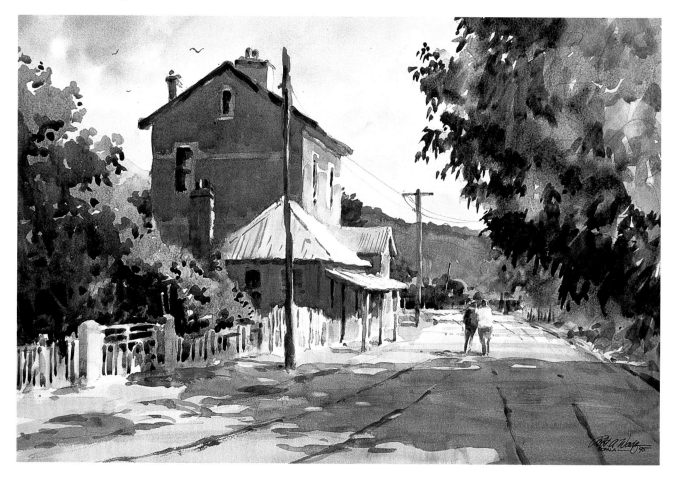

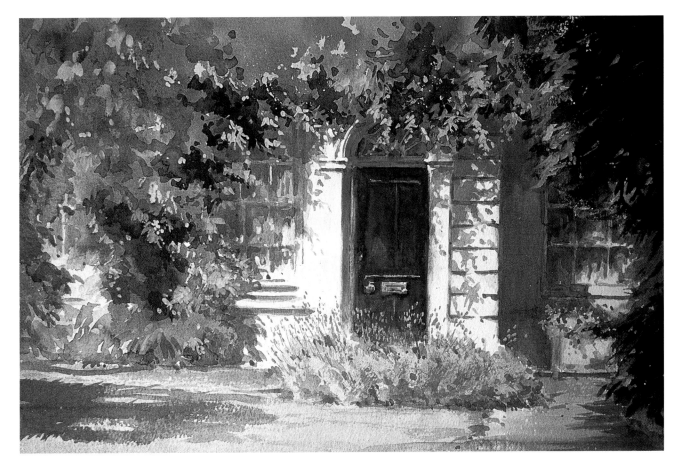

"Whistler's Doorway, London",
14 x 21" (36 x 53cm)
Lots of different foliage textures set off the light shape around the door. The house in Chelsea is a National Trust building and is regarded as historically important. It should be, too. I wonder how many artists will be remembered as historically significant at the end of this century? Not many. I'll bet! Opaque pigment was used for foliage highlights and the heads of lavender.

"Church at Salford, Oxfordshire", 14 x 21" (36 x 53cm)
I enjoyed painting the big chap on the right, feeding wet color into wet color and allowing the medium to do its thing. This was painted on tinted Bockingford.

"Kingston Heath, 14th"
Oh no! Not another golf course! The trees are massed, with the foliage shapes joining. See how the darks at the back are pushing the light shapes forward.

**"Summer in Vermont, USA",
14 x 18" (36 x 46cm)**
The patterns in the foreground grass were fun to make. I had to be careful not to make them too interesting or they may have stopped the viewer from looking further back into the subject.

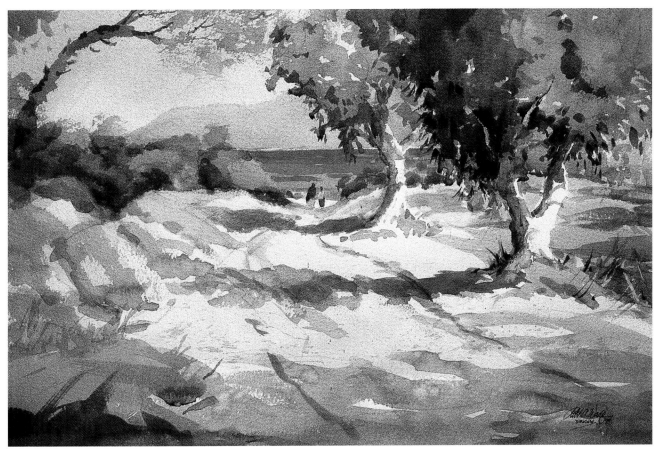

**"Anzac Cove, Gallipoli, Turkey",
14 x 21" (36 x 53cm)**
This was a very emotional class demonstration painted at Anzac Cove, scene of a major battle in WW1 involving thousands of young Australians and New Zealanders. It was wanton slaughter of the cream of our youth and I sobbed shamelessly thinking about it. It's very difficult to paint when one can't see the paper!

"Port Clyde Rooftops", 11 x 14" (28 x 36cm)
Foliage occupies about one-third of the space, the greens change constantly, as does the shape of the foliage.

PAINTING PEOPLE IN YOUR PAINTINGS
SHOW ME HOW THAT WORKS

Understand figure proportions. I won't give you a lot of highly technical details but I must give you a few things to remember about proportions of the figure. The most critical points of all are these:

ABOUT 8 HEADS HIGH

ABOUT 7½ HEADS HIGH

The average male figure of roughly 6 feet tall, is near enough to 8 HEADS HIGH.

The average female is about 7½ HEADS HIGH.

Give or take a fraction, these proportions will always allow you to paint figures that look good and are completely acceptable and believable — that's all we ever want to do!

Some other basic proportions are:

- Shoulders are three heads wide approximately.

- The distance from the chin to the top of the forehead is about the length of a hand. (To check this, place the heel of your palm at the bottom of your chin and extend your fingertips to the top of the forehead. When the arms are hanging by the side the tips of the fingers are roughly half-a-hand above the knees.)

These measurements are all approximate, but if you can keep somewhere in these sizes your figures will have a feeling of normality about them.

Practice measuring members of your family using the old thumbnail-on-pencil trick and just check me out on these proportions.

Whenever I jury shows anywhere around the world I'm constantly amazed at the lack of ability that many painters display when painting figures. I'm not talking about large figure studies that are usually painted by people who know what they are doing. I'm talking about the small figures that do so much to lend scale, movement and life to paintings. What amazes me most is the fact that the funny little shapes are meant to be people and they're painted by other people. We look at people every day, we are people ourselves, so how come when we paint them into our work we don't recognize those shapes as being very wrong, appearing more like wombats than humans?

I've seen so many otherwise reasonable watercolors totally ruined by the inclusion of shapes that look like aliens from outer space, cartoon characters gone wrong, or midgets with oversize pumpkins for heads! I can just imagine the thought patterns: "I should put in some figures, but I'm not too good at them. My painting desperately needs some life in it to help make it more interesting but I may muck it up altogether. What should I do?" There's little chance of success after that, because the seeds of doubt will flourish and bear fruit very quickly. The artist's hand is trembling, the brush is shaking and only divine intervention can prevent another major disaster occurring. Oops, too late! Ruined it again!

Confidence is extremely important in the handling of watercolor and the only way to acquire it is to practice. Fill dozens of pages of sketchbooks with figure drawings, both from life and from imagination. Draw people at every opportunity until you've lost your FEAR of them. Fear, that little

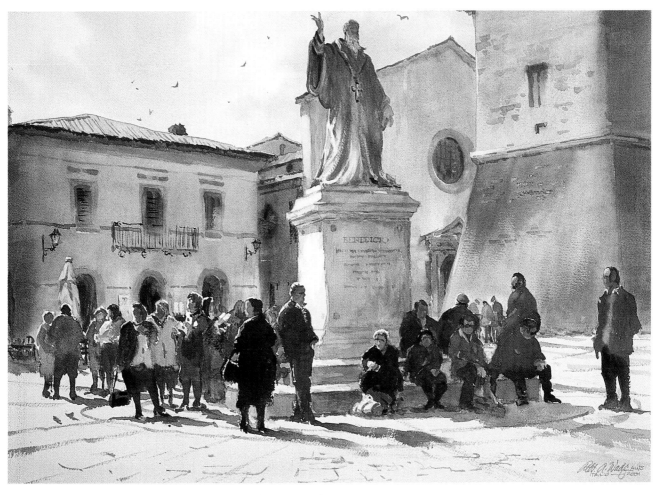

"The Benediction, Norcia, Italy", 15 x 24" (38 x 61cm)

four letter word that is the ruination of so many paintings. Only by constantly drawing and painting people can you build up your confidence and tackle the task in a positive way, knowing that your figures will appear as believable shapes.

Once you can do this. you will open up a whole new world of subjects — market scenes, beach scenes, street scenes, crowd scenes, and so on. Your paintings will look so much more professional when your figures look like real people.

Your paintings will look much more professional when your figures look like real people.

BOB'S BLOBS

Before I ask you to produce some painted figures I want you to try out my "Bob's Blobs" exercise. It's designed to give you confidence in making figure shapes believable, to become aware of proportions and to lose that fear. This is great fun to do, and suddenly you'll find that it's not nearly as difficult as you thought.

Why do we want to put figures into our paintings? Often it's for scale, so that we can mentally evaluate the size of objects in relation to the average 6' male figure. If there are no people about when you are out on site, and believe me, if they are present they'll never be where you want them anyhow, you will have to invent some. How to make them the correct size? Look for a reference point. There may be a nearby building, in that case, look at the doors which will be about 7' high. It is then just a matter of drawing a figure that could walk through that space with something to spare. Voila! It works. If there's an automobile parked in your picture area, and it's a standard family sedan, then the top of the roof will be about shoulder height for a male.

Don't be too rigid, just put down loose shapes like these.

Work quickly — they're not portraits, so just add blobs to suggest heads. Angle the legs. Vary the weight on the brush.

By making comparisons between shapes, we are able to make drawings which are representative of our subjects.

When you have produced many pages of "Bob's Blobs" and you feel confident that your proportions are making good looking figure shapes then you can begin to invent some individual figures.

For faces, make a blob, then press a tissue into it. Suddenly, faces appear.

BOB'S BLOBS

Don't just read about all this. Trying these ideas for yourself will help you remember the main points.

1 Begin with two figures simply standing still. Don't start with people serving tennis balls, jumping hurdles or performing a one-and-a-half somersault with pike! You can't play a Mozart concerto until you've learned to play the scales — and we're in the same situation here. Crawl before you walk, and don't try to tackle things that are beyond your capabilities at the moment.

2 Start by making single figures from your imagination. I want you to get into the habit of inventing figures so that you'll be able to pop them into your work at will. If you use too many reference photos for this purpose then you'll have a tendency to overwork the figures, they will become very noticeable and the purpose of having them in your picture will be defeated. Keep them as simple, silhouette type shapes without facial features. Indicate a presence, rather than a personality.

LEARNING POINT
When you know in your heart that the shapes you are making really do look like people, pick out an old failed painting and drop a couple of figures into the picture. As you've already classified that painting as a flop, there won't be any pressure on you to cause a shaking, nervous hand to ruin your newfound skill. Allow some edges of your people to run and link with the background. You do not want them to look as though they've been cut out and then stuck down on top of the painting.

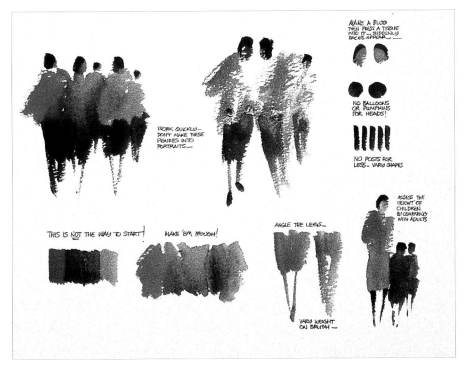

Fill dozens of pages of sketchbooks with figure drawings, both from life and from your imagination. Draw people at every opportunity until you've lost your FEAR of them.

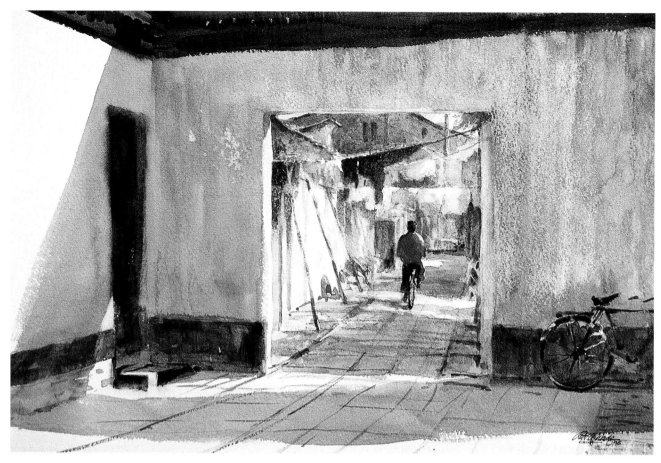

"A Wall of China", 14 x 21" (36 x 53cm)
Only a solitary figure, but it is extremely important, because it takes the eye right in through the opening. This painting won an award at the Grand Prix d'Aquarelle in Trégastel, France.

When considering adding figures to a completed painting try this. Take the glass from an old discarded frame and place it over your painting. Decide where you think you want to place the people then **PAINT THEM ON THE GLASS. If** they look good, then you can proceed, but if you think they don't do the job then nothing's lost and your painting is safe.

This sneak preview is a good idea if you're ever thinking of adding anything — from automobiles to telegraph poles! It can save a lot of heartbreak.

"Rice Paddies, Bali", 14 x 19" (36 x 48cm)
The figures were all placed to encourage the eye to move in an elliptical path around the painting, but the people still look natural as they perform their daily work. The painting is owned by Mr. Tony Bennett.

6

SUBJECT SKILL
BUILDING

118

"Roman Library",
The scattered small figures are just so important in giving scale to the ruins. See how the injection of color into the cast shadows and reflected lights make the whole painting sing.

"Subway Silhouettes",
14 x 11" (36 x 28cm)
Great shapes, no facial features. Do you think that faces would have improved this? I don't. I want to indicate a presence, not a personality!

SELF-ASSESSMENT CRITIQUE

Drag out those old paintings again and physically measure any of the figures that you've included. I'd be very surprised if they are not mostly on the short side, probably 4 or 5 heads high.

If your pictures are framed, then paint on the protective glass and enlarge the shapes to our 7-8 heads high. Doesn't that look better? Now they look more like humans. However, we may have created a new problem. The proportion of the figures to the buildings could give the impression that the figures are ten feet tall. So you see how difficult it is to change the size of figures in watercolor!

LEARNING POINT
To begin with, make the heads smaller than you think you should. It's easy to enlarge them if necessary but difficult to reduce the size of the head if it's too large. The only thing left in that circumstance is to enlarge the body but in that case the figure almost certainly could look like a giant.

6

119

Now it's time to look at the business of art — everything from thinking about your image, photographing your work and keeping records, approaching a gallery, entering art shows and even dealing with rejection. Welcome to the real world.

THE BUSINESS OF ART
TELL ME HOW THAT WORKS

When the motives of artists are profound, when they are at their work as a result of deep consideration, when they believe in the importance of what they are doing, their work creates a stir in the world.
— Robert Henri

BEING IN BUSINESS
TELL ME WHAT I NEED TO KNOW

Some artists believe they are superior people because of their ability to paint. Not many, thank goodness, because the majority of us feel that we are certainly very privileged to have been given the ability to see beauty and communicate it. But, in fact, we are really only manufacturers. We make a product and market it just as a shoemaker, a cabinet-maker, a house builder or any other skilled artisan does.

1. THINK ABOUT YOUR IMAGE
If we're professional full-time artists then we must run a business and be businesslike ourselves in our dealings with galleries, clients and suppliers. The image of unwashed, unshaven and untidy artists is one that really bugs me. I believe this is usually a mask for their own incompetence and they believe they are presenting the image many people expect of artists.

I remember attending a glitzy, black tie Awards Dinner many years ago. I was sitting at a table of strangers and during dinner we never actually discussed art. When the awards were announced I went forward to receive the Gold Medal for Watercolor. On my return to the table, the lady sitting next to me leaned across and said "Oh Congratulations! I had no idea that you were an artist. You don't look the part at all. You have short hair and clean fingernails, I thought you were probably a banker!" I hope she went home with a new idea of how artists look. Well madam, I would have made more money if I had been a banker, but I would never ever have had the great personal rewards that I've had in my career of watercolor. The very few people who let the side down by their appearance and demeanor get very short shrift from me.

So because it's a business we're running, it should be run in a professional systematic fashion. It would be just terrific if we could spend every day involved only with the act of painting. In my case, correspondence, filing, receipts, keeping sales records and maintaining systems that keep the tax man happy, writing magazine articles, phone calls from all around the world, paying bills and banking, consumes an enormous amount of

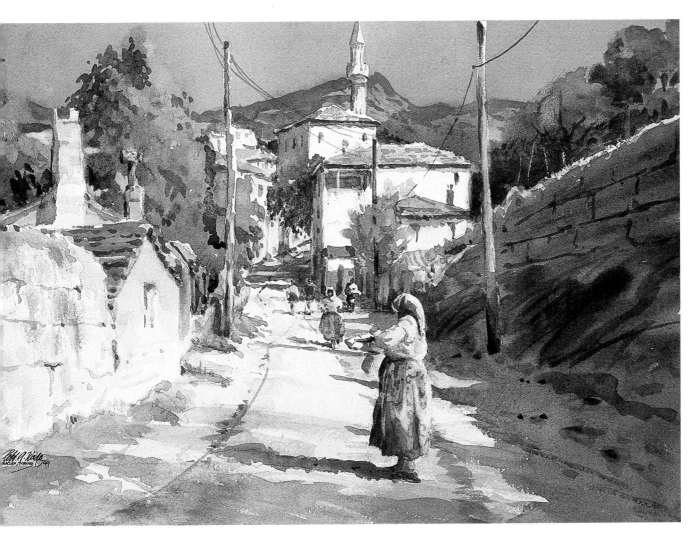

"Main Street,
Heraclea, Turkey",
15 x 20" (38 x 51cm)

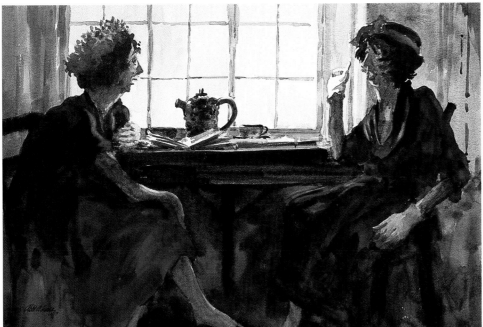

"Old Gossips",
15 x 20" (38 x 51cm)

"Side Street, Arles",
13 x 10" (33 x 25cm)

my time. Suddenly, I find it's Friday morning and I'm getting to paint for the first time this week. However, that's the way it goes and if I'm lucky then next week I'll spend three days painting — wow!

2. ADOPT SYSTEMS TO KEEP TRACK OF YOUR WORK

I have a system for cataloging all of my paintings. In my logbook I write the title, size and the type of paper for each work I do.

In addition, I make a small line drawing of the image so that if I have to refer back to a painting with a title like "Venetian Canal", it will be obvious which one it is, because I may have painted dozens of different places in the canals of Venice.

Each painting has a file number that is written on the margin. It will be something like 01/6-32. This shows it was painted on 01/6 June 2001 and number 32 means it was the 32nd watercolor for the year. If a framer or a collector quotes me that number from the back of a painting, then I can go to my logbook and instantly obtain the relevant information.

I will also have taken a color slide of the finished painting and it will be filed away under that number.

If ever a gallery or magazine phones and requests a transparency of a particular painting which was done a few years back you must know how to locate it. If you don't have a system you could be in deep trouble. This is easy to do, quick to maintain and it works. Try it!

3. TAKE PHOTOGRAPHS OF YOUR WORK

Always photograph your work with the thought that the transparency will be needed for submission to a juried show, so it needs to be good. Maybe you might get a professional photographer to shoot your paintings, but I prefer to take my own photographs. I've also had some taken professionally, but I think mine are better.

I've been taking slides of my work for many years and I know that watercolors are not easy to photograph. Transparent watercolor allows the paper to shine through and that's what tricks the light meters.

- I use Fuji 100 ASA slide film that gives me the closest result to my actual colors, and the slower 100 ASA speed gives a much better saturation.
- When I take my photographs I shoot in a bracket of three. The first shot is as the light meter reads it, the second is one stop above that and the third is one stop below the meter reading. Usually the one below the reading will turn out to be the best result.
- I never use artificial light for photography. I like to take the shots outside, on a bright, overcast day with an excellent even light. Never have your painting in direct sunlight. Perhaps that might work in some parts of the world, but it doesn't in Australia. The result would be very overexposed, the meter again being tricked by the light reflecting back.

Should you want to submit a particular painting for a show but none of your slides quite turned out, then forget it. Don't send a second-rate slide. Jurors will reject it right away if they can't get a clear view of the work, so save your time. Send another slide or none at all.

4. DON'T SELL YOUR BAD ART

Professional artists must sell or they starve — simple as that! However, there are some thoughts that I want to have you ponder upon. DON'T SELL EVERYTHING YOU PAINT!

None of us produces work of such consistently high standard that every painting is worthy of a frame. Creativity ebbs and flows and every now and then it flows out before you've finished, leaving behind an "almost, but not quite" result. Only YOU will know that it's not up to your standard, the average person will think that it's great. Therefore you'll be tempted to sell if the opportunity arises — DON'T! Never prostitute your art. Unto thine own self be true. It's amazing, but, just as in life, your indiscretions can come back to haunt you. I know that awful feeling of seeing a painting that was done many years ago and then flinching and thinking, "How embarrassing. Did I do that?" Well, if you stop and consider that it was as good as you could do at that time and that it was painted in all sincerity, that's OK. However, should you remember that even then you thought it wasn't too good, but still sold it, wouldn't that be just awful?

5. DON'T SELL YOUR BEST ART

Every now and again the opposite will happen and bingo! something very special will result from your efforts. That's one to keep for your own walls, if possible. If you sell that one you will always regret it.

Over the years I've been able to retain watercolors which have won international awards. I'm so pleased that I have them hanging in my own home to pass on to my family eventually. I could have almost named my price for some of them, but I knew that if I sold them, sooner or later I'd be sorry.

"Montepulciano, Tuscany", 11 x 14" (28 x 36cm)

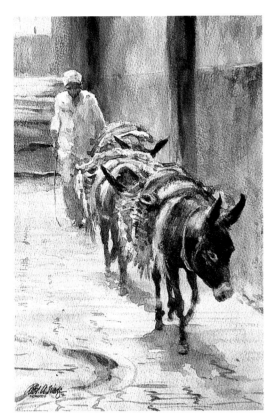

"Corner in the Forbidden City", 11 x 14" (28 x 36cm)

"Delivery Service, Morocco",
14 x 11" (36 x 28cm)

6. KICK-START YOUR ART CAREER

To find your place in the art world begin by showing in local art exhibitions. Take part in four- to six-person group shows. Don't become overexposed — don't allow your work to be seen everywhere. My policy has been to have a solo show about every three to four years, then people will ask, "When is your next show?" and look forward to seeing it. That's so much better than having them receive an invitation every year and thinking, "Not again! Seems like only yesterday that we saw the last one!" It's a slow process and, as John Pike wrote to me many years ago, "Anyone who thinks that it's possible to earn a good living from just painting watercolors must be out of their mind!"

My advice to parents who have children with lots of drawing ability, is always to suggest that the kids do a graphic arts course and make a career in the graphics. Earning a steady income allows the freedom to paint at night and weekends without the constant worry of feeding and clothing a family. In the fullness of time, when children have finished their education and moved out, if you have persevered and developed your skills and sensitivity, then you may be able to make a career in art. But it's tough, there is lots of competition and there's not a big enough market of buyers with money in their pockets.

If you want to play the gallery game then go for it! Select a few potential galleries that you'd like to have represent your work. Make some inquiries about the way they operate, and how they stand in the opinions of other artists.

7. GET INTO A GALLERY

The big questions that confront the aspiring painter are, "How do I get into a well known gallery? Where can I begin to have my work seen, noticed and purchased?" These questions are very difficult to answer. My observations tell me that far too many painters rush into solo exhibitions long before they are ready for that major step upwards. I believe it's better to wait until you feel your work measures up to the high standard of work you've seen in the local galleries, and be honest about it.

If you begin your public career with a second-rate exhibition of very ordinary watercolors, that memory will remain with collectors long after you've achieved much higher status. I honestly believe that half the exhibitions I attend should never have been opened. Don't listen to what Aunty Mary, or your best friend, has to say about your work — they are heavily biased, and kind. They are very proud of you, very supportive and encouraging, but have no knowledge of art. You are the only one who knows where your work stands. Don't rush in before it's ready for the open market or you'll regret it. I had my first solo show at the age of 52, when I knew that I was more than ready. It was a sell-out and confirmed my decision to wait before taking the big plunge. The wonderful British artist, Hercules Brabazon didn't have his first one-man show until he was 71. By that time his work was so good that when John Singer Sargent attended his London exhibition he was influenced to concentrate on small, impressionistic watercolors too.

SET UP TO MEET A GALLERY OWNER

Prepare a folio of TOP works, or TOP photographs of your work, and make a professional presentation. That's easy to do now with computers, word processors, scanners and color printers.

Phone the Gallery, having already learned the director's name. Here's how it should go.

"Good morning, Briarside Gallery."
"Am I speaking to Mr. James Oliver?"
"Yes you are."
"Mr. Oliver, my name is William McKenzie, I'm a watercolorist of some ten years standing. I know and respect your gallery and I would very much like the chance to call on you and present my work. I wonder if it is possible for me to make an appointment to come and meet you?"

That's enough, don't rave on, be precise and businesslike.

Now, if Mr. Oliver is a good director he'll want to see your work. As far as he knows you could be another Andrew Wyeth or another John Yardley, and he can't afford to pass up that opportunity. He'll only need to look at half-a-dozen works to know whether you're good enough to interest him, so make sure that you show him only your best. Don't be apologetic: "This is not a very good photo Mr. Oliver, the actual painting is not nearly as dark and the colors are much brighter". Anything that doesn't measure up has to be left out of your presentation or you won't get to first base.

Have your CV ready if asked for it, but don't start with it.

If the director has no place for you in his gallery, close by saying something like:

"Mr. Oliver, I do appreciate you allowing me to take up your time. Can I possibly come back in 12 months for you to see the progress I'll have made?"

You've done your very best and you've tried to leave the door open. You can't do more than that. If you didn't make it there then try the other galleries.

Persistence has its own reward. Meanwhile, keep trying for the shows, start locally, gradually building up to state societies and eventually national shows. If you have some success, drop a note to Mr. Oliver and let him know, it could just change his mind. The main thing for you to do is make sure that you only exhibit your best work wherever it's going. The art-buying public is pretty darn smart, and you can't hoodwink them, even if you would want to do that!

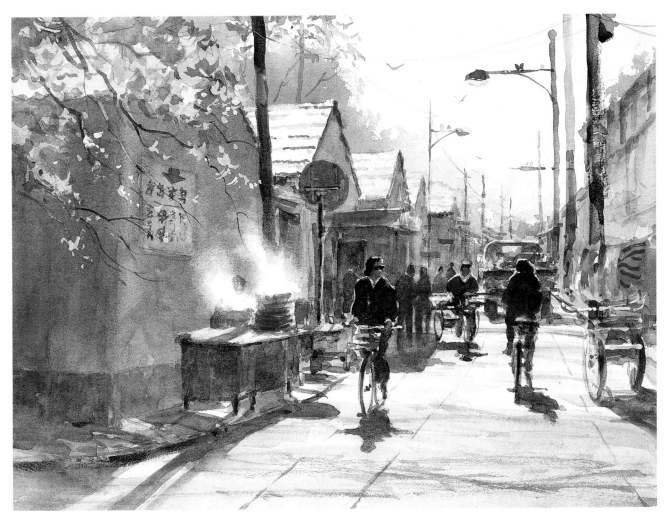

"Street in Beijing, China"

CONCLUSION — WHERE DO YOU GO FROM HERE?

From the preceding chapters you have acquired the basic techniques and knowledge to enable you to paint. I can give you all the information, but I cannot give you the determination to progress and grow. That must come from within you. An overpowering desire to paint at ever higher levels of competence. An overwhelming urge to FEEL the bond between yourself and your subject and then communicate it to the viewer. Ambition is a very important part of the painter's personality, and without it there is no stimulus to arouse your enthusiasm and compel you to go forward in the face of failure and rejection.

BEAT THE REJECTION BLUES

Have you missed out on gaining selection for that big show which you so desperately wanted to make? If you

have, then welcome to the club. You are certainly not Robinson Crusoe — the only person on the island! I have probably been REJECTED from more major shows than any artist I know! Nobody, but nobody, wants to receive that dreadful REJECTED slip in the mail, rather like a parking ticket on your car. You feel you have just been kicked right in the teeth, and the "masterpiece" that you sweated over, fretted and worried about, and then finally considered to be good enough to submit, has been passed over by the Jurors.

What a great blow to your pride. What a feeling of resentment. What a bitter pill to swallow this can be! Do I like being knocked back? No I don't. Who does? However, there are quite a few guidelines in jurying a show, and it is just as well to consider some before blowing your top.

The judge, or panel of Jurors, will have a number of requirements in making their choice of paintings, not the least of which will be to present a well-balanced exhibition from the work submitted. Now, if you happen to have painted a large vase of white daisies, and so have ten other artists, then someone must miss out, and bad luck if you are one of them! We never get to know why we didn't make it, so we are left to wonder why.

I could tell you about some of my unjust, unfair, totally biased, politically influenced, ignorant, spiteful, malevolent rejections!!!!! At least these are the sort of thoughts which spring quickly to mind. However, having been in the role of Judge so many times myself, I know that this is not the case. The one thing the Judge is trying so hard to do is to be fair and honest. All paintings must be selected in an

anonymous way, with total disregard for the name of the artist.

This is not all that easy because, like our handwriting, an artist's style is so personal that the signature is almost unnecessary, but it must be absolutely ignored when making decisions. Because it is usually a panel making the selection of works in the major exhibitions, it means that a majority decision is necessary, so that if two Jurors really love your work, but three are only so-so then, sorry old chum, you have missed the boat!

The American Watercolor Society's Annual Exhibition in New York is perhaps the most prestigious in the world, certainly one of the most difficult to achieve selection, so everyone wants to be hung in an AWS show. Submission is by 35mm slide, one only per artist, and usually there are 2000-2500 applications. From these, the Jurors have the monumental task of choosing about 100 works for the show! This means that about 1-in-20 gets in, and that sure is tough competition. I have submitted annually since 1981, have been successful just three times, in 1981, 1993, and 2000, and that's a long time between drinks!

The Royal Institute of Painters in Watercolours, London, works on a different system, and the only submissions possible are actual framed works. It makes for a very expensive freight bill, especially as each artist may submit up to six framed pieces. When your freight to London is adding up to some hundreds of dollars, then rejection hurts even more, right in the hip pocket! I submitted to the RI annually for ten years, and each year some were accepted, but one year not a single one got into the show.

Well, do I feel embarrassed to disclose my rejections to you? Not at all! Every painting submitted to these distinguished Societies was my best possible work at the time, and if they were not good enough, then I tried harder. Remember this: Constant acceptance breeds complacency and mediocrity. Rejection breeds

determination and ultimate success. Don't harbor grudges against the Judges, determine to paint something better to submit next year. So, if at first you don't succeed, then you can count yourself as pretty normal! Rejection helps to keep us humble, (and so does watercolor) and it's extremely good for the soul.

My father wrote the following message in my autograph book when I was about eight-years-old. I didn't understand it at the time but, as the years rolled by, its meaning became abundantly clear. It became my motto, and is still my driving force, even after all these years.

"Good, Better, Best, never let it rest, till your Good is Better and your Better, Best".

It's a message for life, not just painting. To be the best person you can be, to do a job to the very best of your ability, to continually strive to be the best. That constant goal which will never be achieved, is the carrot dangling before our noses, the carrot that motivates us to work harder and harder to try to achieve the next level in the pursuit of excellence. I wonder if my dear dad ever realised that he was setting the pattern for my entire life? I hope so.

Robert Browning wrote, "Oh that man's reach should exceed his grasp, or what's a Heaven for?"

The search for knowledge never ends and nobody knows it all! I remember visiting my old friend Roland Hilder, one of England's finest watercolorists of the 20th century and, as was my custom, I went down to Blackheath with my folio in hand so that he could see what I'd been doing of late. One particular painting had a passage that had virtually painted itself, I had merely encouraged and watched it happen and Roland quickly latched onto that. "I say old chap, that's superb! How did you do that?" He was very excited by that small chance happening in my painting and I thought to myself "This man is 86 years of age but still seeks knowledge of the medium that most people believe he has completely mastered!"

Aren't we so fortunate to be involved in this wonderful business? The oldest student I've ever had attended a workshop on Fraser Island when she was aged 93, and she and her husband both painted with me. I was very touched by her desire to learn more at that age. She was a very experienced painter and showed the young ones a thing or two! What courage, what determination!

On that same workshop I had with me a man who was totally crippled by osteoarthritis. He was totally restricted to his wheelchair, and his wife (a real angel) did everything for him. He was a mouth-painter and he worked with a framework over his head to steady the brush and to take some of the pressure off his head. John Butler and his wife were a constant source of inspiration to all of us as we witnessed his great courage and enthusiasm to paint better. He was an excellent painter but they were both wonderful people. I sent them a Christmas card that I painted with a brush in my mouth. It was so difficult, it gave me even more respect for this dedicated man and his disability. We, who are so fortunate, must develop our given skills to the best of our ability.

For all of my painting life, it has seemed to me that art and music go hand in hand, and I always paint with music playing in my studio.

My old friend, Tony Bennett, that wonderful American singer who is still going strong and performing around the world at age 75, agrees with me on this fact. Tony is also a noted artist and has received much acclaim in the United States for his sensitive paintings. Personal interpretation is the key factor in both of his two fields of endeavor.

A long time ago Tony recorded a "Golden Oldie" with the lyrics:

"Wrap your troubles in dreams and dream your troubles away!"

Maybe this could be the watercolorists' theme song!!

Just for fun, I'm going to call on some great old songs which seem pertinent to the artists. In the early 30s Bing Crosby sang a popular song,

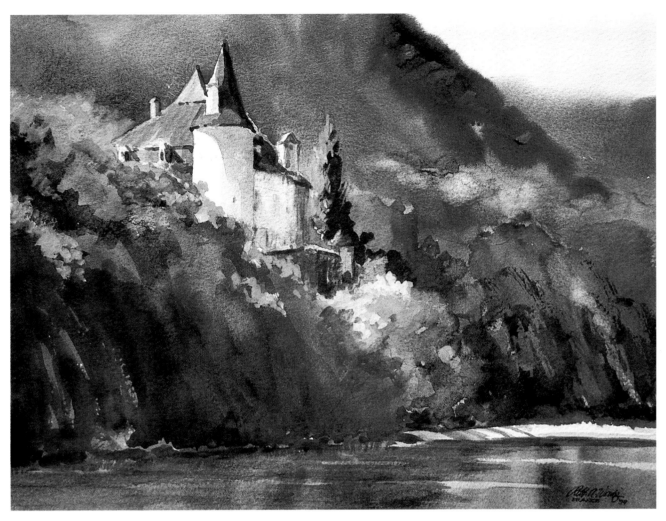

"Chateau near Souillac"

which began with these words:

"I'm no millionaire, but I'm not the type to care,
'Cos I've got a pocketful of dreams."

These very words could just about be pinned across the top of my studio noticeboard. Guess that I've always had a pocketful of dreams! As a child I tended to dream, to imagine, to romance. I still do, actually, and this is an excellent starting point for all of our paintings.

WE ALL NEED TO DREAM A LITTLE ABOUT OUR SUBJECT, to imagine something other than that which is apparent, to inject some drama or romance in order to make an artistic statement that is entirely personal.

Peggy Lee sang another great old standard:

"Imagination is funny, it makes a cloudy day sunny."

How frequently today I am still doing all the imagining stuff that

I call VISIONEERING in order to portray the subject in a way I have imagined, making it more interesting to the viewer and expressing a more personal interpretation of the facts before me.

Barbra Streisand sang this beautiful song:

"Memories, from the corners of my mind,
Misty, watercolor memories of the way we were."

Isn't this a touching description of scenes from our sketchbooks that sometimes float before our eyes and result in some very special paintings?

I guess what I want to point out to you is this: there is an ingredient in a painting that only YOU can put into it! It is your personal reaction to what you see in the subject, rather than a report of the facts that are apparent to everybody.

It's an injection of feeling (cameras

can't do this) which will elevate your work from the pack and it will come as a result of your dreaming, your imagination and your memories.

The subject is there before you, but it is only the starting point. I want you to have complete freedom to move, delete, reorganize, reproportion or change any shapes, elements or values you consider to be vital to the success of your work, and that may result in a more pleasing and sensitive rendering of the subject. Remember that we are not reporting on a set of facts, we are making a very personal statement about our reaction to something that has stirred our emotions in such way that we have been compelled to paint it, in order to communicate and share our feelings with others.

"Dreams, and they may come true,
Dream, that's the thing to do."

Oh well, play it again, Sam! Here's to watercolor!

ABOUT THE ARTIST

Distinguished Australian artist Robert A Wade was born in Melbourne in 1930. He has gained international acclaim for his sensitive and varied watercolours, and his work has won over 100 awards in Australia, England, France and the USA, including 8 major awards from the Salmagundi Club, New York, the Cornelissen Award of the Royal Institute of Painters in Watercolours, London, two awards from the Grand Prix d'Aquarelle, Trégastel, France, and three Gold Medals from the Camberwell Rotary, Australia.

His watercolors are represented in many major collections, including the Brooklyn Museum, New York; Salmagundi Club, New York; World Museum of Watercolor, Mexico City, and many corporate, golf club and private collections world-wide.

Bob is a very generous and much loved instructor, and is generally regarded as one of the world's foremost contemporary painters and teachers of watercolor. He has taught workshops in many countries in Europe, most States of the USA, New Zealand and Australia.

He is the author of two best selling art instruction books and two videos, he has been a consultant to both *Australian Artist* and *International Artist* magazines since their inception and has written numerous articles for both publications.

Robert Wade is a Signature Member of the Australian Watercolour Institute; he is a full Signature Member of the American Watercolor Society; a Member of the International Society of Marine Painters USA, Knickerbocker Artists USA and he is a Fellow of the Royal Society for the Arts, London.

Dubbed "the Unofficial World Ambassador of Watercolor" he has painted in 40 different countries. His name is synonymous with watercolor all around the world.

Website: www.ozemail.com.au/~rawade